HOW TO DRAW

HOW TO DRAW

José M. Parramón

The historical background,
materials and tools,
techniques and procedure,
theory and practice of the art of drawing

Watson-Guptill Publications/New York

© Parramón Vilasaló, José M.
Copyright © 1991 by Exclusifs edition rights, Parramón Ediciones, S. A.

First published in 1991 in the United States by Watson-Guptill
Publications, a division of BPI Communications, Inc.,
1515 Broadway, New York, NY 10036.

Library of Congress Cataloging-in-Publication Data

Parramón, José María.
 [Cómo dibujar. English]
 How to draw / José M. Parramón.
 p. cm.—(Watson-Guptill artist's library)
 Translation of: Así se dibuja.
 ISBN: 0-8230-2352-4
 1. Drawing—Technique. I. Title. II. Series.
NC730.P2713 1991
741.2—dc20 90-49325
 CIP

Manufactured in Spain
Legal Deposit: B-8.887-91

1 2 3 4 5 6 7 8 9 / 95 94 93 92 91

Fig. 1. (Previous page).
Copy from a pastel of
Eugène Delacroix. (See
page 22, figure 47).

Contents

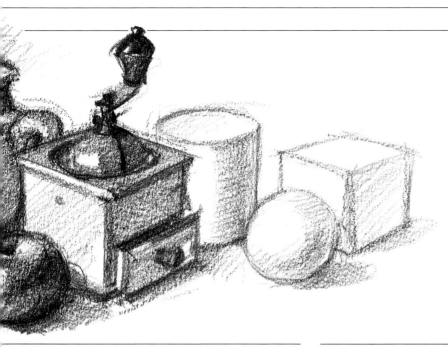

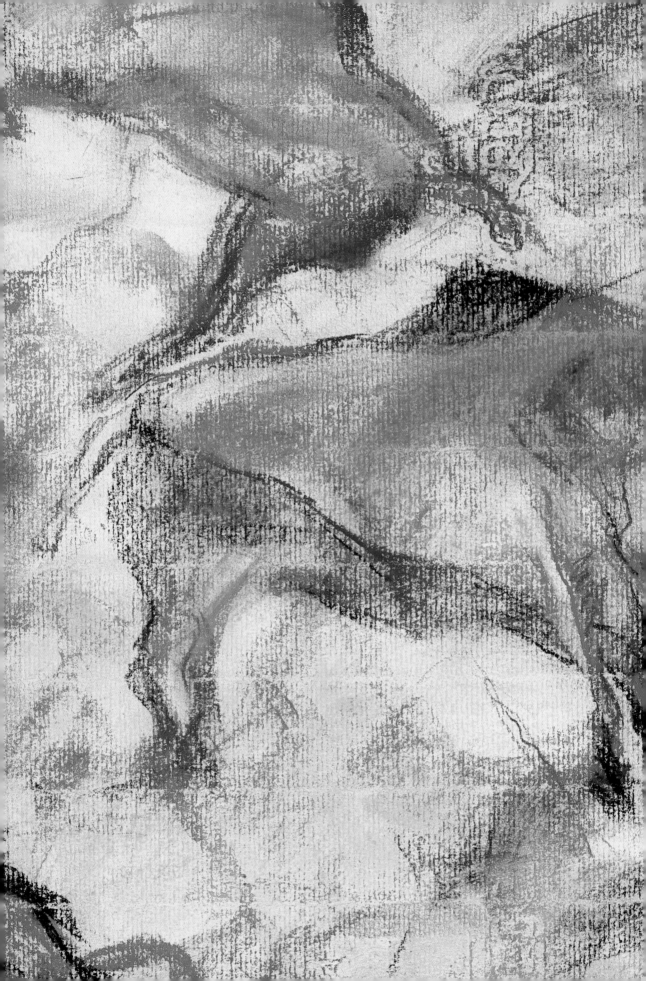

It all began more than 20,000 years ago, when Paleolithic people began to draw horses, bison, and gazelles on the rock walls of the caves they lived in. Then, thousands of years later, the craftsmen of ancient Egypt elaborated on this basic art form with graphics and drawings painted on papyrus and on the walls of their tombs. Next it was the Greeks' turn with such artists as Polygnoto, Phidias, and Apelles, and then their successors, the Romans. The Romans copied the Greeks, but in the Middle East, in the Islamic countries, and in the Far East, the art of painting and drawing took on styles peculiar to these regions of the world.

In the Middle Ages, art in the West went through a period of stagnation, producing little of note for hundreds of years. But in the Renaissance, to quote the Swiss historian Jacob Burckhardt, "Man discovered the world and himself." Great artists such as Leonardo da Vinci, Michelangelo, Raphael, Titian, Correggio, then Dürer, and the Carracci revolutionized the way people saw themselves. Later, in the seventeenth century came Rubens, Velázquez and Rembrandt. In the eighteenth and nineteenth centuries came the development of watercolor, with Turner and rococo, then neoclassicism in the Romantic period, were followed by realism and impressionism, right down to modern art with its multitude of "isms." This is just a brief summary of the fascinating history of drawing that we offer you in the following pages.

2

A short history of the art of drawing

Prehistory

The origins of known artistic activity date back some 20,000 years, to the paintings of bulls, bison and horses that our ancestors made on the walls of the caves they lived in. These wall paintings seem to have had the function of magical invocations, rites to ensure success in hunting. They were engraved in the rock with flint burins, and their realism is remarkable. These primitive artists reinforced the outlines of their work with charcoal, then painted over it with colors, using rudimentary brushes made of animal hair, binding the paint with animal fat, resin or blood.

Egypt

The art of ancient Egypt has a direct relationship with the beliefs of the society of the time. The pharoah was considered a divinity, and everything concerning his image and his life had to be appropriately reproduced with a view to the afterlife he would go to at his death. This explains why such a large proportion of Egyptian painting is found in the tombs of that country.

Fig. 2. (Previous page). Copy from Altamira paintings.

Fig. 3. Bison. Altamira Cave. Santillana del Mar, Santander, Spain. More than 20,000 years ago, Paleolithic people painted animals on the walls of the caves they lived in to appease the gods of wild game and fish.

Fig. 4. Bison engraved on a deer's horn, found in the Madeleine Cave. Saint-Germaine-en-Laye Museum, France.

Fig. 5. *Banquet*, detail. Tomb of Djehouti (1448-1422 B.C.), Thebes. Harmony of line and brilliant use of color are two outstanding features of all Egyptian mural paintings, whose pictorial beauty goes hand-in-hand with narrative clarity.

Greece and Rome

There is a tremendous sense of order as well as a great variety of subject matter in Egyptian painting. Before an artist began painting, he made preparatory sketches on limestone or pottery slates called ostraka; the final work would then be painted on a wall using pigments fixed with gum arabic and eggwhite, with a brush made of fine cane fibre.

Greece and Rome

An ancient story has survived that tells of a fifth-century B.C. Greek painter named Zeuxis, whose art reached such a state of perfection that a bird tried to peck at a bunch of grapes he had painted in one of his works. However, the drawings and paintings decorating the urns and bowls of the ancient Greeks reveal art of great quality and originality that emphasizes elegance of line. The style reached the height of its harmonic expression in the 5th and 4th centuries B.C. in what we know as the classical period. Roman art as a reflection of the Greek begins in the 6th century B.C. The Roman works that have been preserved to the present day, frescoes, mosaics, pottery and so on, show that the Romans took their inspiration from the Greeks.

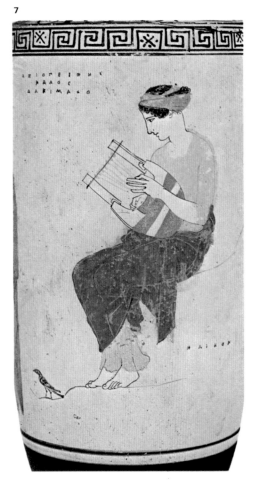

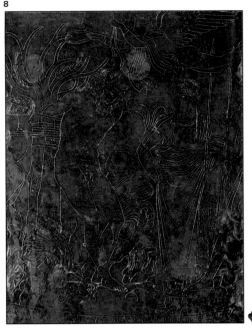

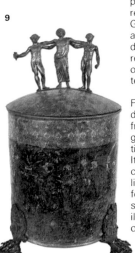

Fig. 6. Greek funeral vase (5th century B.C.), known as a *lekito*, featuring a drawing on a white background. Private collection.

Fig. 7. Detail from fig. 6. The correct representation of proportion, simplicity of composition and linear harmony of classical Greek drawing have gone down in history as the basic norms of artistic excellence to a point where these works still provide inspiration for artists, even today.

Fig. 8. Detail from fig. 9. The engraving of this *cista*, one of the masterpieces of Etruscan art, reveals the influence of Greek art in its precision and linear richness. The drawing of the figures is reminiscent of the decorations on Greek pottery.

Fig. 9. *Cista Ficoroni*, decorated with scenes from the myth of the Argonauts by Novius Plautius. Villa Giulia Museum, Italy. *Cistas* are cylindrical coffers with feet and lid. The handles are formed by small bronze scuptures (those of this illustration represent Dionysius flanked by two satyrs), the surfaces engraved by burin.

Oriental and Islamic art

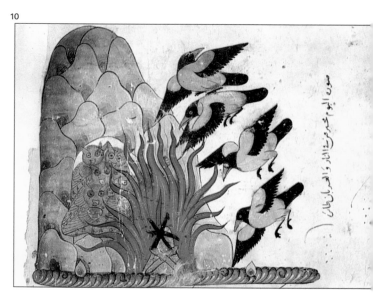

10

By the seventh century A.D. the Islamic faith had spread to cover an area extending from Tibet to the Atlantic coast of Africa. The art of Islam is in part derived from that of the countries conquered during the spreading of the religion. Although the Koran prohibited the depiction of living creatures in art, a great many figurative works were produced in Syria, Persia and Mongolia, works that demonstrate a refined taste for the arabesque and a magnificent richness of color.

In Buddhist India the art of the fresco reached extraordinary heights during the Middle Ages, only to decline towards the thirteenth century as a result of the rise of illustration of texts and the painting of miniatures. The miniatures were made on palm leaves. Moslems, who predominated in the north of India, employed paper from Persia for their miniatures, which clearly reflected the influence of Persian and Mongolian art on them.

Fig. 10. *Crows Setting Fire to Owls*, Syria, 1325-1350. Bibliothèque Nationale, Paris.

Fig. 11. Katsushika Hokusai (1760-1849), *The Wave: Mount Fuji seen between Waves*. Österreichisches Museum für Angewandte Kunst, Vienna. Hokusai was a famous prolific Japanese artist of the last century. A painter, draftsman and illustrator, his drawings form an encyclopedia of life in Japan. His compositional sense had a strong influence on the impressionist artists.

11

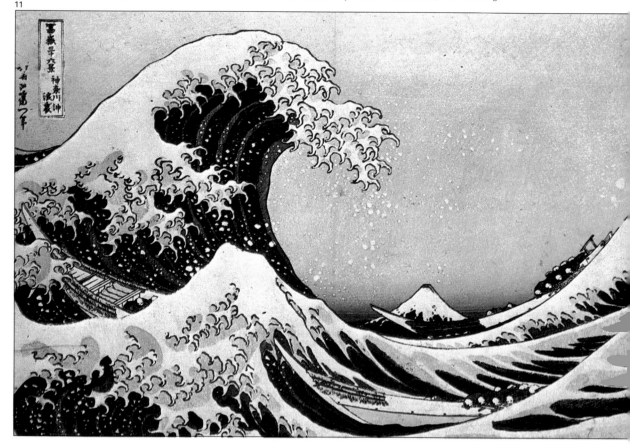

Art in the Middle Ages

The culture of Europe in the Middle Ages was dominated by the conventions and principles of the Christian religion rather than the pagan cultures of the Old World. So it is that, in medieval art, themes are almost exclusively religious, there are no nudes, and the sensuality of classical art is avoided.

The origins of medieval forms are to be found, on the one hand, in the ornamental art that flowered in Northern Europe during the time of the Carolingian Empire, in the seventh and eighth centuries, in which the mastery of the Irish miniaturists was outstanding, and, on the other, in the influence of Byzantine art, which was the inspiration behind the development of the romanesque style of the eleventh and twelfth centuries. Towards the end of the 12th century, the advent of gothic art heralded the close of the "Dark Ages," bringing all the art forms of the medieval period to their culminating point of refinement.

Fig. 12. Anonymous. *Book of Lucianus* (9th century). The illustration shows an engraving representing Hyginius.

Fig. 13. Anonymous. *Volumen of Joshua*, Vatican Library. A *Volumen* is a sheet of parchment rolled up in a wood cylinder. This example depicts the life of Joshua, drawn in pen-and-ink and wash and brush by a 9th-century Byzantine artist.

The invention of paper

Paper was first made in China in the year A.D. 105. The invention was brought to the West by the Arabs, who founded paper factories in the Middle East, North Africa, and Europe. By the end of the fourteenth century, paper was in common use among artists, who sometimes dyed it different colors. In the eighteenth century, the Englishman John Whatman and, a century later, the Frenchman Etienne Canson made important innovations in the creation of drawing paper.

Figs. 14 and 15. The starting point for making paper by hand is a paste consisting of water, glue and natural fibers, into which a sieve is placed to strain enough paste for one page (fig. 14). Once drained, it is placed over another sheet protected by pieces of felt, and the pile of sheets is pressed (fig. 15) and hung up to dry.

The Quattrocento

The fifteenth century in Italy was one of the most fertile and creative periods in the history of art. Padua, Ferrara, Mantua, Venice and, above all, Florence were the Italian cities that saw an extraordinary boom in artistic activity. The most important noble families competed for the services of sculptors like Donatello or painters like Piero della Francesca, pioneers of the new Renaissance style. It was Piero who first formally used perspective, which had been introduced with the greatest mathematical rigour by the architect Brunelleschi. Piero also wrote a book to guide his fellow painters on the practice of his discipline, showing how the artist must cease to be a pure craftsman and begin to incorporate the findings of the sciences and the arts into his work becoming a humanist.

Drawing, too, became an obligatory skill, a demonstration of mastery in which the artist used all the tools at his disposal, charcoal, pen, watercolor, chalks, the metal pencil, and so on.

16

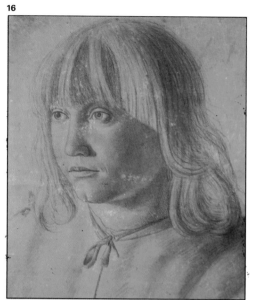

Fig. 16. Antonello de Messina (1430-1479). *Portrait of a Young Man*. Albertina Museum, Vienna. Charcoal on paper dyed sepia. Antonello is one of few Italian artists to reflect the influence of the Flemish Van Eyck's love of detail.

Fig. 17. Sandro Botticelli (1445-1510). *Allegoric figure*. British Museum, London. Outline in black chalk, drawing in sepia ink and sepia watercolor, with highlights in white chalk, on paper dyed pink.

Fig. 18. Lorenzo de Credi (1459-1527). *Portrait of a Man*. Louvre, París. Metallic pen on paper dyed light yellow.

17

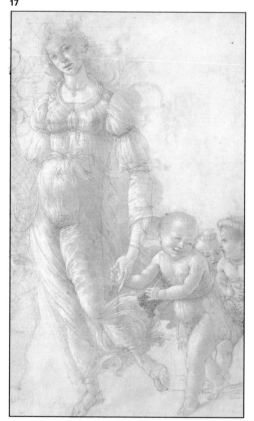

18

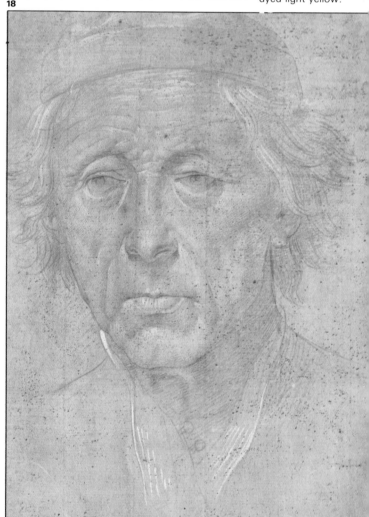

Leonardo da Vinci

The name Leonardo da Vinci (1452–1519) immediately conjures up the Renaissance. Indefatigable scholar, writer, botanist, geometrist, and inventor, Leonardo was the prototype of the universal man, one for whom the sciences and the arts were just two sides of the same coin, two activities dedicated to the same end: understanding the secrets of nature. As an artist, he produced few works, but all of them are masterpieces. He introduced innovations in all the fields of artistic creation: with the invention of *chiaroscuro*, the use of lights and darks, he ushered in a new age in the history of Western art. His sketches and notes show his ceaseless investigation of the picture plane and an extraordinary inventiveness technically. He experimented with all the techniques and methods known in those times, and used new materials, achieving works of enormous energy and admirable subtlety.

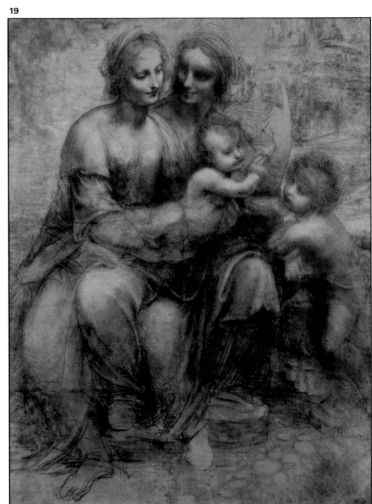

Fig. 19. Leonardo da Vinci (1452-1519). Madonna and Child with St. Anne (Estudy). National Gallery of Art, London.

Fig. 20. Leonardo da Vinci. *Self-portrait*. Royal Library, Turin. Sanguine.

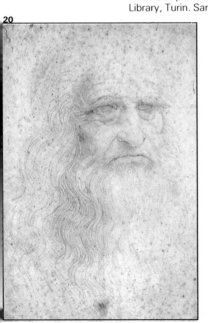

The metallic pencil

This is an instrument with a lead or silver point which produces a dark line similar to that drawn with the lead pencil of modern times.

The metallic pencil was known to the ancient Greeks. It came into common use in the Renaissance in part because of the production of drawing paper which the artist could dye in different colors. The reader can try drawing with this instrument by taking a short length of lead or tin, sharpening the point and

applying it to the paper, preferably couched paper, in the same way as demonstrated in figure 21.

Michelangelo

Michelangelo Buonarotti (1475–1564), thought of as the greatest sculptor who ever lived by many artists and scholars, attained fame at a very early age. By the age of 21 he had already completed one of the most famous works of the Renaissance, the *Pietà*, which stands in St. Peter's in Rome. A few years later, he sculpted his *David* from a gigantic block of marble, a medium no other sculptor dared to attempt modeling. He also designed the monumental dome of St. Peter's. Commissioned by Pope Julius II, he painted the greatest series of frescoes in the history of art on the ceiling of the Sistine Chapel in the Vatican. But he accepted the commission reluctantly, as he did not think of himself as a true painter.

Fascinated by the human figure, Michelangelo made anatomical studies by dissecting human bodies in times when he could have been imprisoned for such irreverence. However, his perfect knowledge of anatomy enabled him to produce extensive studies of the human figure. He used his powerful modeling style to depict the most daring contortions of the limbs in these sketches, and they have been a resource for whole generations of artists who have copied them time and again seeking to grasp the teachings, aspiring to emulate the skill of the master.

Fig. 22. Michelangelo Buonarroti (1475–1564). *Study for the Libyan Sybil.* For the murals of the Sistine Chapel. Metropolitan Museum of Art, New York. One of many studies the artist made for his renowned work. Sanguine on cream paper.

Fig. 23. Michelangelo Buonarroti. *Male Nude.* Louvre, Paris. Pen-and-ink in bister. Michelangelo made numerous studies of this kind, in which he perfected his portrayal of human anatomy.

22

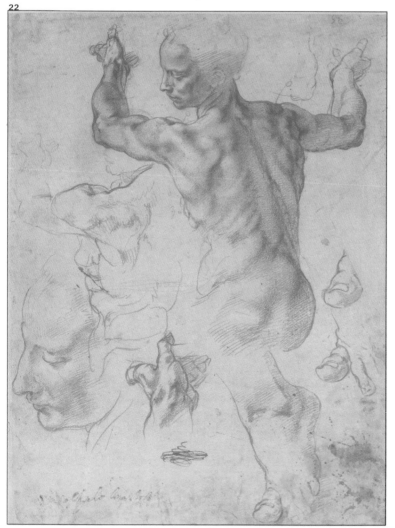

23

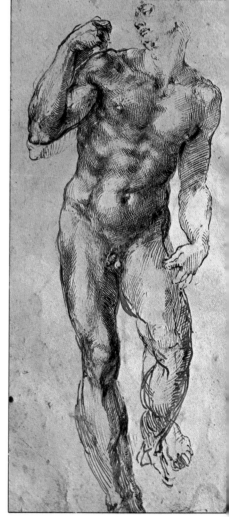

Raphael

ig. 24. Raphael (1483-520). *Study of a Figure or a Resurrection*, detail. shmolean Museum,)xford. Though the influence of Michelangelo s obvious, Raphael's reatment of volume is always gentler.

ig. 25. Raphael. *Study f Heads and Hands for he Transfiguration*. Asholean Museum, Oxord. Here is a fine examle of Raphael's skill in rawing and modeling he human head.

Raffaelo Sanzio, or Raphael (1483–1520), son of an Urbino painter, received his early training in the shop of Perugino, a painter with a gentle, balanced vision. The influence of Perugino is reflected in the golden tones, the spacious landscapes, and the simplicity of composition in his early work. Raphael's constant striving for perfection led him to study and assimilate with the styles of his predecessors with great facility. From Leonardo he learned *sfumato*, a technique for defining form with the gradation of tones from dark to light, the pyramid-shaped composition, and a serene relationship between figure and landscape. Later, he was attracted by the force of Michelangelo in his portrayal of movement in his nudes and by the tonal contrast of Venetian painting.

When Raphael was 25, Pope Julius II commissioned him to decorate the apartments of the Vatican, and a year later on the basis of the rooms he designed, his reputation had grown even to overshadow that of Michelangelo.

He was a tireless draftsman, and it is in his drawings that one best appreciates the freshness and invention of figures' poses. He never falls into exaggeration or becomes mannered. His output of portraits was immense, and besides the technical perfection and harmony in them, what is outstanding is the humanity with which he portrayed Renaissance princes and ladies.

4

25

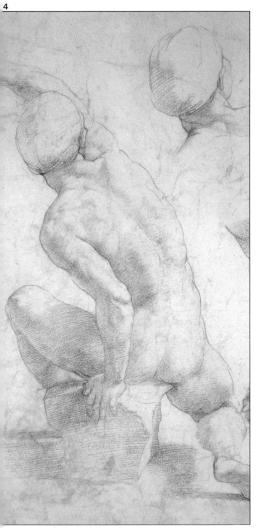

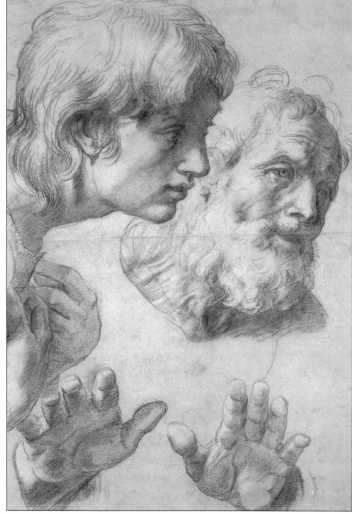

The Cinquecento

The opening decade of the sixteenth century witnessed the consolidation in Venice of a new concept in art, one far removed from the rigorous constructions of the artists of Florence and Rome. Painters like Giorgione (ca. 1477–1511) and Giovanni Bellini (ca. 1430–1516) began to give their pictures form through the use of tonal contrast and pure colors, a technique that would be perfected and brought to brilliant fruition by three grand masters: Titian (ca. 1488–1576), Tintoretto (ca. 1518–1594), and Veronese (1528–1588).

All three were superb draftsmen, using mainly charcoal, black chalk (a pigment extracted from coal), or "Italian stone," similar to the charcoal pencils in use now though rather softer. Since they were colorists, in their drawing rigidity of line gives way to great masses whose form is defined through value contrast.

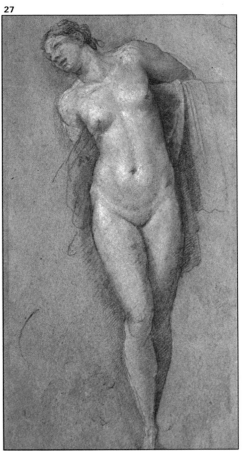

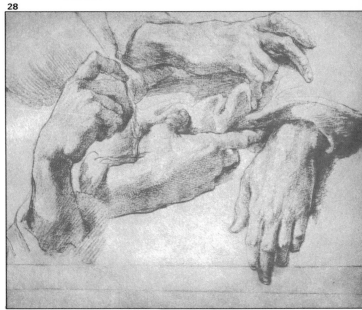

Fig. 26. Titian (ca. 1488-1576). *Jupiter and I.* Fitzwilliam Museum, Cambridge. In this drawing Titian did not seek detail but the structure of the masses within a homogenous whole.

Fig. 27. Sebastiano del Piombo (1486-1547). *Standing Nude.* Drawing Archives, Louvre, Paris. Charcoal with highlighting in white chalk, on paper dyed blue.

Fig. 28. Andrea del Sarto (1486-1530). *Study of Hands.* Drawing Archives, Uffizi Gallery, Florence. Sanguine. A contemporary of R0mans Raphael an Michelangelo, del Sart was one of the most f mous painters of 16t century Florence. Th study was made for or of his most renowne frescoes, the *Miracles S. Filippo Benizzi.*

The Renaissance in Europe

Developments in Italian art soon began to cross the frontiers into the rest of Europe. Artists in other countries followed events in Italy closely, and many visited the country to study. Such painters as Cranach (1472–1553), Grünewald (ca. 1465–1528), Baldung (ca. 1484–1545), or Dürer (1471–1528), though developing wholly personal styles, were strongly influenced in their work by Italian art. The most outstanding of these was Albrecht Dürer who, after a laborious apprenticeship as an engraver in Nuremburg, twice visited Italy, where he became familiar with the work of the Venetian painters and became interested in humanistic studies.

Dürer's enormous oeuvre combines the passion for detail typical of German art with the search for geometric harmony that was a constant in Italian painting. A master of the art of engraving, Dürer was also an early master of watercolor.

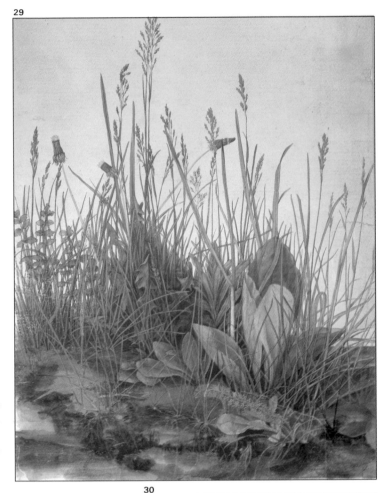

Fig. 29. Albrecht Dürer (1471-1528). *The Great Clod (Grass)*. Albertina Museum, Vienna. This is one of Dürer's best-known watercolors. Dürer can justly be called a pioneer of this technique.

Fig. 30. Albrecht Dürer. *The Four Horsemen of the Apocalypse* (fragment). One of hundreds of drawings produced by this supreme master of the art of engraving.

Wood-cutting

Albrecht Dürer was an expert engraver in wood and copper. Woodcutting is carried out on the plain surface of a block of wood cut plank fashion, the artist removing the parts which are to be left white with a graver or burin, and a gouge, leaving the black parts of the work, lines or patches, in relief. Once the image has been engraved, the surface is inked and a sheet of wet paper is placed over it. The paper is pressed against the wood with a burnisher, and thus the image is printed. *Etching* is done on a metal plate, usually copper, which is varnished with a solution impervious to acid. The etcher draws with a needle, exposing the metal where he wants to print. The plate is then put in a nitric acid bath which eats away the exposed parts. The rest of the varnish is removed, and the plate is inked, so that the ink lies in the grooves created by the acid. Finally the image is printed onto a sheet of paper with a handpress.

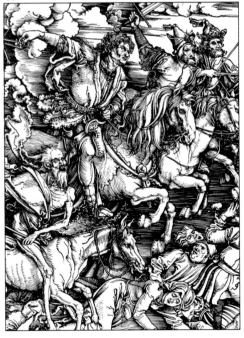

Baroque: Rubens, Rembrandt, Velázquez

By the beginning of the seventeenth century, the hegemony of Italian art had been lost and, although Rome was still an important center of artistic creation, cities such as Antwerp, Seville, and Amsterdam were now coming to the fore, and it was these cities that housed the workshops of three great masters of Baroque art. Rubens (1577–1640), in Antwerp, set up a shop where many artists worked to his orders and under his tutelage, producing hundreds of works destined for nearly all the courts of Europe. Rubens was a man of great culture and refinement, an avid art collector and an artist with great versatility of style, ranging from the heroic pathos of his larger works to the tender intimacy of his portraits.

While Rubens traveled all over Italy in his desire to learn all that he could from the great artists of that country, Rembrandt (1606–1669) spent all his time at his workshop in Amsterdam, where he experienced both fame and wealth and oblivion and poverty. The moving dramaticism of his art exploits the tech-

31

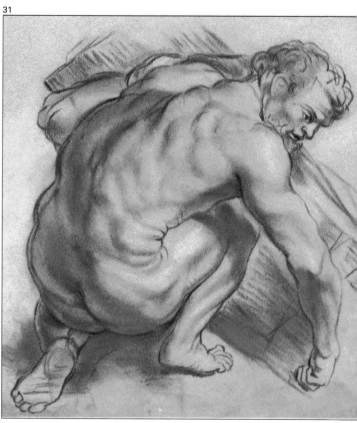

32

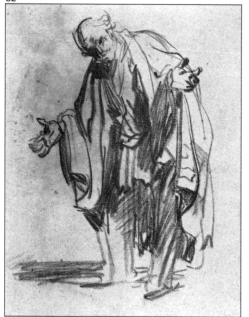

33

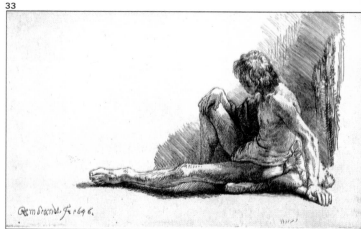

Figs. 32 and 33. Rembrandt (1606-1669). *Old Man Making a Gesture of Welcome*. Gëmaldegalerie, Alter Meister, Dresden, and *Boy, Seated*. Het Rembrandthuis, Amsterdam. Two pen-and-ink notes revealing Rembrandt's extraordinary skill as a draftsman.

nique of chiaroscuro to the full in compositions charged with imagination and sensuality.

Velázquez (1599–1660) was trained as a painter in Seville, but he was soon called to Madrid to become Court Painter, thanks to the perfection of his austere naturalism, enriched by his emulation of the color of Rubens and the Venetian school.

Fig. 31. Copy of a drawing by Peter Paul Rubens, known as the *Study of a Nude Man with a Heavy Object*. Louvre, Paris. Dark sienna chalk with highlights in white chalk on a cream background.

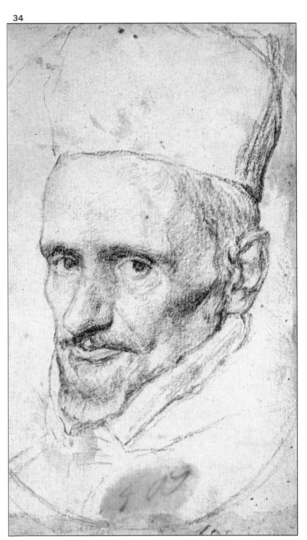

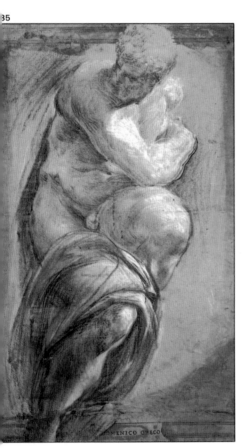

Fig. 34. Velázquez (1599-1660). *Head of Cardinal Borgia*. Real Academia de San Fernando, Madrid. This is one of very few drawings by Velázquez in existence. Charcoal.

Fig. 35. El Greco (1541-1614). Study of *Day* by Michelangelo. Pinacoteca, Munich. Charcoal on blue-gray paper. Although El Greco was critical of the work of Michelangelo, he drew *Day*, one of the master's scuptures in the Medici tomb.

Fig. 36. Pieter Bruegel the Elder (1530-1569). *Summer*. Kunsthalle, Hamburg. Pen-and-ink. Also known as "Peasant Bruegel," he was a brilliant landscape painter as well as the greatest Dutch draftsman and satirist of his time.

The eighteenth century

In the eighteenth century, drawing on paper saw a spectacular rise in popularity. In Italy, particularly in Venice, artists like Canaletto (1697–1768) and Guardi (1712–1793) sold their *vedutti*, views of the city (etchings and pen-and-ink drawings) to mostly English tourists. (It was precisely in England that the watercolor, which developed in part from these vedutti, became a truly national art form, with J.M.W. Turner [1775–1851] the indisputable master of the technique.) In the France of the period, called rococo, drawing techniques were splendidly refined by such artists as Fragonard (1732–1806), Boucher (1703–1770), and Watteau (1684–1721). A technique much used in those times was that of the *dessin à trois crayons* (using charcoal, red chalk and white chalk on colored paper). The pastel drawing also flourished in the hands of portrait artists such as Rosalba Carriera and Jean-Baptiste Perroneau.

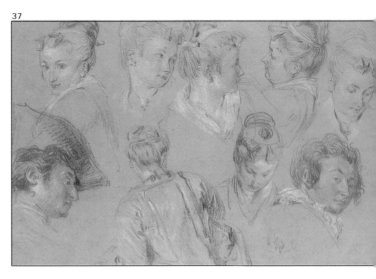

37

Fig. 37. Jean-Antoine Watteau (1684-1721). *Studies of Five Heads*. Louvre, Paris. Black chalk and sanguine on cream paper, with highlights in white chalk. This combination of three colors, a technique that became popular in 17th-century France, is known as the ''dessin à trois crayons.''

Fig. 38. Francesco di Guardi (1712-1793). *Caprice, Inner Portico of the Church*. Correr Museum, Venice. Guardi was best known for his ''vedutti,'' views of Venice, sold to English visitors to the city.

Fig. 39. Sir Joshua Reynolds (1723-1792). *Study of a Head*. Tate Gallery, London. Charcoal pencil. Reynolds is the most famous 17th-century English portrait artist, founder and first president of the Royal Academy. He was a master of portraying spontaneity, as this drawing reveals.

Fig. 40. Alexander Cozens (1717-1786). *Composition for a Landscape*. British Museum, London. India ink and brush.

38

39

40

Fig. 41. J.M.W. Turner (1775-1851). *Venice: View of the Giudecca, Sunrise*. British Museum, London. Painted by Turner during one of his journeys to Venice, generally considered the period in which he produced his finest watercolors.

Fig. 42. Pierre Paul Prud'hon (1758-1823). *Female Nude*. Louvre, Paris. Charcoal pencil with highlights in chalk on blue paper.

Fig. 43. Francisco de Goya (1746-1828). *The Disasters of War; With or Without Reason*. National Chalcography, Prado, Madrid. Etching.

Fig. 44. Jean-Auguste-Dominique Ingres (1780-1867), *Nude in Oil*. Ingres Museum, Montauban, France. Ingres made this study for one of the figures for his painting *The Turkish Bath*, an example of academic art and sensuality.

41

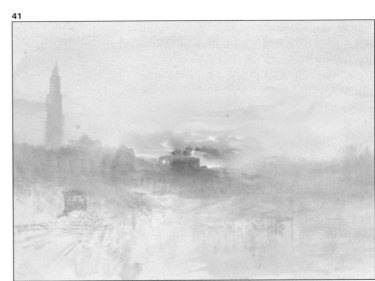

42

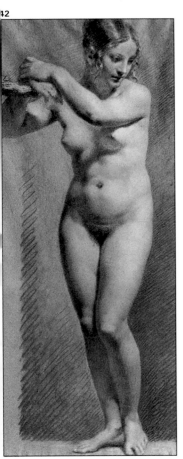

43

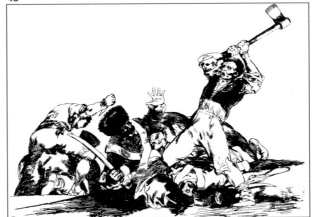

44

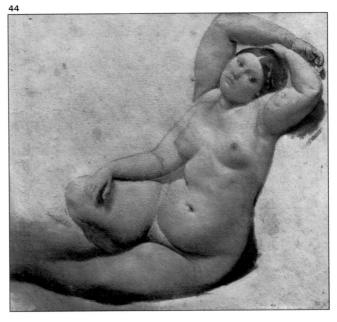

The nineteenth century

Drawing at the beginning of the nineteenth century was romantic and realistic. Later the most important styles became an expression of the changing states of nature by the impressionist painters; at the end of the century, they were the driving force behind the development of modern art.

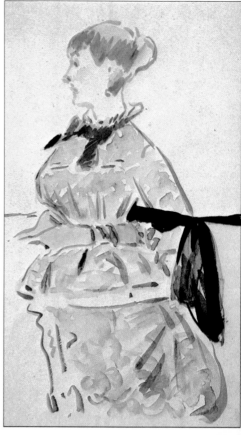

Fig. 45. Eduard Manet (1832-1883). *Isabelle Lemonier, 1880.* Louvre, Paris. The quick sketch, aimed at capturing the first impression, was a basic idea of the Impressionists, whom Manet supported and defended.

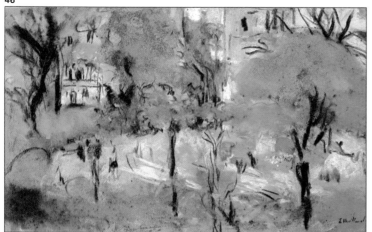

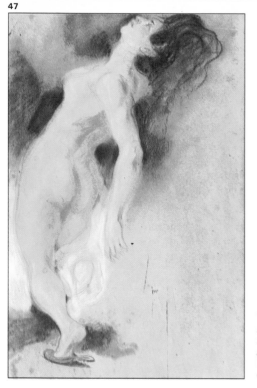

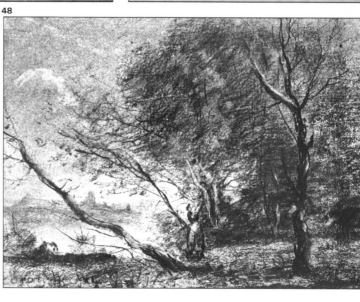

Fig. 46 (Above). Edouard Vuillard (1868-1940), *Place Vingtmille Seen from the Artist's Apartment.* Private collection. Pastel. Vuillard, master of broken color ranges, shows us in this example of his work just how relative the importance of theme is.

Fig. 47. Eugène Delacroix (1798-1863). *Study for the Death of Sardanápale.* Louvre, Paris.

Fig. 48. Jean-Baptiste-Camille Corot (1796-1875). *Landscape*. Louvre, Paris. Charcoal.

Fig. 49. Claude Monet (1840-1926). *Waterloo Bridge, London*. Louvre, Paris. Pastel.

Figs. 50 and 51. Vincent Van Gogh (1853-1890). *Sailing Boats at Saintes-Maries*. Cane and India ink. The Solomon R. Guggenheim Museum, New York. Edgar Degas (1834-1917). *Woman Drying her Neck*. Louvre,

Paris. Van Gogh and Degas offer us examples of their peculiar drawing styles, the spirals or wavy lines of the former and the regular vertical strokes of the latter.

Fig. 52. Paul Cézanne (1839-1906). *Pistachio Tree in the Courtyard of the Chateau Noir*. Louvre, Paris. Pencil and watercolor on paper.

49

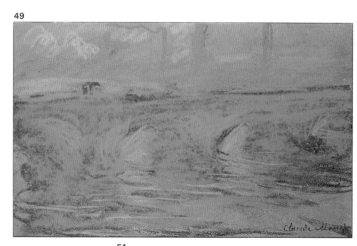

50

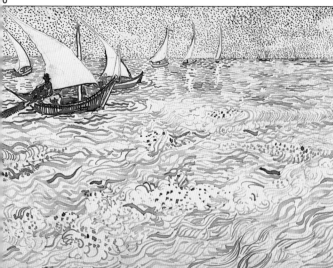

51

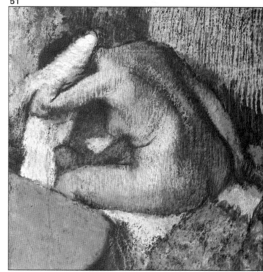

52

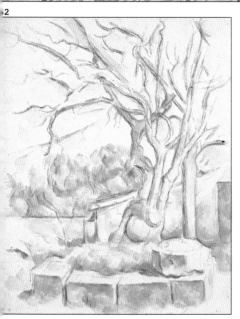

53

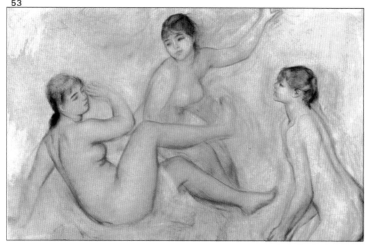

Fig. 53. Auguste Renoir (1841-1919). *Three Girls Bathing*. Louvre, Paris. Pencil, sanguine, and highlights in white chalk.

The nineteenth and twentieth centuries

In terms of artistic expression, the end of the nineteenth century and the beginning of the twentieth was a time of tension. Drawing became less naturalistic, more cerebral, synthesizing forms and using color to greater dramatic effect than ever before. Artists like Toulouse-Lautrec (1864–1901), Schiele (1890–1918), Matisse (1869–1954), and Grosz (1893–1959) sought intensity of line and innovation in the expression of form and color. Picasso (1881–1974) was the personification of this evolution. "I do not look, I find," he declared. He was an example to any budding artist; "to be famous and successful, you have to work," was a favorite phrase of his.

At the age of ten, Picasso began to paint. At sixteen he painted *Science and Charity*, winning an honorable mention with it at the great Madrid Exhibition. In 1900, at the age of just nineteen, he went to Paris for the first time. He spent his whole time there drawing and painting.

54

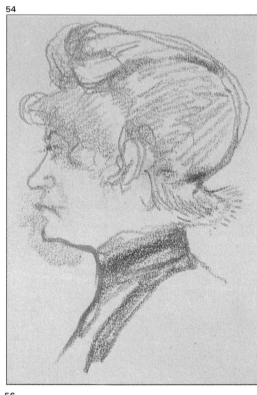

Fig. 54. Henri d Toulouse-Lautre (1864-1901). *Por trait of a Prostitute* Private collection Albi, France.

Fig. 55. Egon Schiel (1890-1918). *Nude* Kunsthistorische Museum, Vienna. A drawing of grea originality in its pose stylization of figure and color.

Fig. 56. Franz vor Stuck (1863-1928) *The Kiss of the Sphinx*. Hermitag Museum, Leningrad An example of force contrast, almost vio lence, I would say but perfectly con ceived and drawn.

55

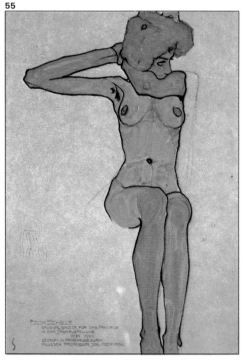

56

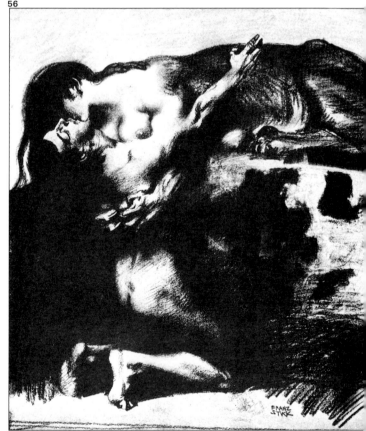

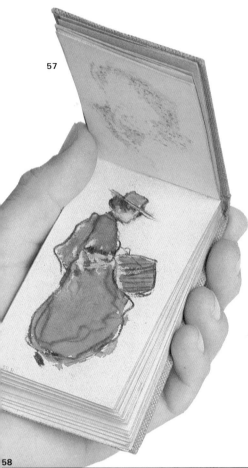

Even when he went out walking, he made small drawings in the sketchbooks he always carried with him (see fig. 57). One year later, his famous "blue period" began, and in 1904 came his "rose period." In 1906, at the age of twenty-five, he invented cubism and completed his first sculptures. He began working on collages in 1912. He painted backdrops for ballets composed by Satie, Stravinski, Falla and Milhaud, as well as portraits of these musicians (see fig. 59) and of poets and painters from his circle of friends. He exhibited his work in Paris, Barcelona, Madrid, London, New York, Munich. Picasso's paintings and drawings were always figurative, never quite becoming abstract. Still, they always had the quality of being different, original, surprising. The work of Picasso forms a brilliant history of the evolution of art in the twentieth century.

Fig. 57. Pablo Picasso (1881-1974) *Profile of a Woman with a Hatbox (Dressmaker's Assistant).* Picasso Museum, Barcelona. Pastel on paper in one of the sketchbooks donated by the artist to this museum. The original size of the block is 105 × 58 mm (42 × 23").

Fig. 58. Picasso. *Woman in the Box.* Collection of Charles im Obersteg, Geneva. Picasso painted this picture in 1901, in Paris, in a style far ahead of its time—one not so very different from what one sees in an exhibition of new painting today. Curiously, Picasso painted another picture on the back of this canvas: *Absinthe drinker.*

Fig. 59. Picasso. *Igor Stravinsky.* 1917. Private collection. Pen-and-ink. Here, the artist portrays this great musician and personal friend with admirable elegance, while employing an original linear style.

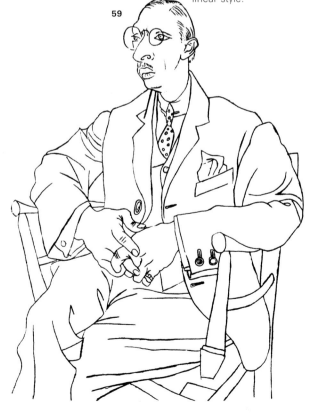

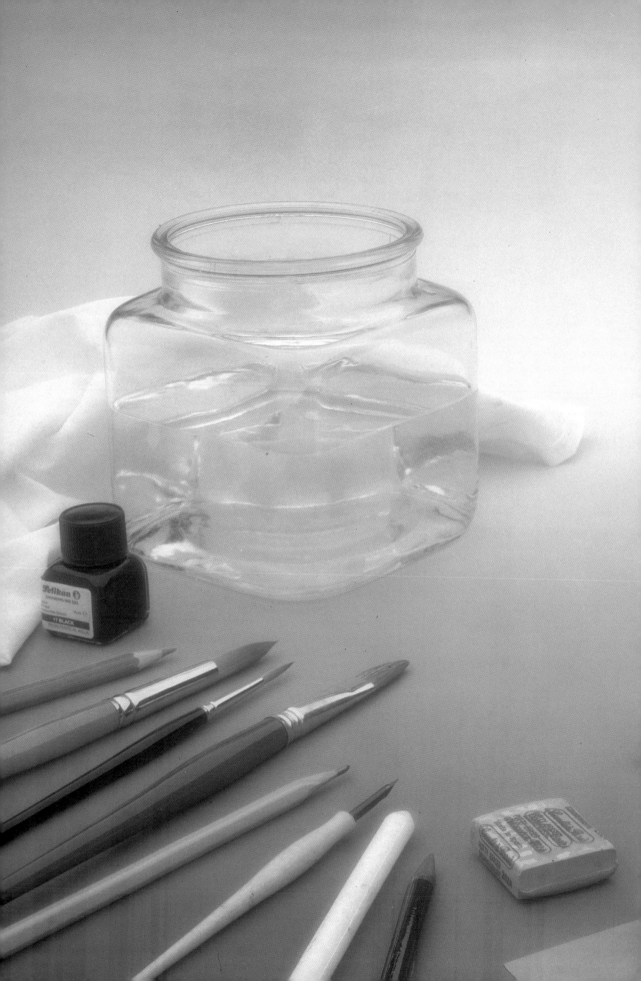

Before learning how, we must first learn with what: what should we draw with, what materials, what tools, in what medium, and with what techniques. You already know what a pencil is, and a paintbrush, and about erasing and stumping, but what about cane? And do you know about the colorless marker? About the "dessin à trois crayons"? Well, perhaps the materials, tools and techniques of the art of drawing have not changed much, but in recent years the makers of drawing and painting materials seem to have felt the need for innovation and invention. One day, you go to your local dealer and find a soft lead pencil made by a well-known manufacturer that draws like a normal pencil except that it is water soluble. It can be diluted with water and spread over the paper with a brush. Then, another day, you find that Faber-Castell has increased its widest range of colors by twenty. The metal box of 60 colors in its handy wooden case now contains 80. Another day, you learn how to get a "pastel finish" with colored pencils, and so on. And that is what we are going to talk about in this chapter, traditional and new techniques, materials and tools for drawing.

Materials, tools, and techniques

First, let's talk about drawing paper

Let's begin by saying that theoretically any type of paper, whether it be white, colored, fine, thick, vegetal paper or wrapping paper, *any* type of paper can be used to draw on. But, of course, if the paper is specially made for drawing, even if it is not the best quality, the results will be better.

The quality of drawing paper depends basically on the raw materials used in its manufacture, whether pure rag paste, rag mixed with wood pulp or recycled paper, and so on. The gumming of the paper is also an important factor in the quality, as its firmness depends on this. Finally not only quality but also the use to which a particular type of paper can be put is the texture and grain of the paper. Paper can be *fine-grained*, *medium-grained* and *rough-grained*. The first two grains can be used for any type of technique or process, while the third is specially made for wash and water-color painting. You'll notice that the grain on the two sides of a sheet of paper is different, but since both sides are gummed, the sheet does not have a front and a back, only two different sides for the artist to choose between.

Good drawing paper is immediately recognizable by its *watermark*, which is dry printed on one side of the sheet.

Figs. 60 to 63. When you are using a procedure involving water, and the paper is not sufficiently thick, it is necessary to wet and stretch the paper to prevent creasing. Wet the paper in a tray or under the tap, then fix it to your drawing board with tape at the margins. Finally, let your paper dry for four or five hours.

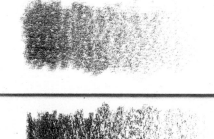

66

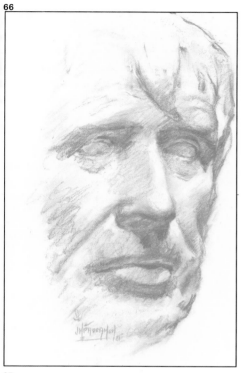

67

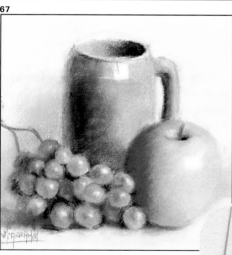

The following manufacturers of drawing paper are among those that can be recommended: Canson, Arches, Fabriano, Schoeller, Grumbacher, Whatman, Guarro. A full list is provided at the bottom of this page. Most of these companies produce both white and colored paper. "Ingres" and "Mi Teintes" by Canson (fig. 68) are the names of two outstanding, wide ranges of colored paper which are ideal for charcoal drawings set off by white chalk and for drawings or paintings in chalks and pastels, wax or colored pencils.

Drawing paper comes in blocks of different sizes, in rolls 2 meters high by 10 meters wide and in sheets measuring 50 × 65 cm (20 × 26") and 70 × 100 cm (28 × 40"). These are the most common sizes in Spain though sizes vary depending on the manufacturer. In England, for example, there are six different sizes, the smallest of which is the 38 × 60 cm (15 × 24") Mitad Imperial and the largest the 79 × 135 cm (31½ × 54") Anticuario.

Fig. 64. Drawing paper can be bought loose or in bound blocks.

Fig. 65. Different types of drawing paper—from top to bottom—fine medium-, and coarse-grain, shown with gradations drawn in lead pencil. The last sheet shows Ingres paper, with a gradation made with charcoal pencil.

Figs. 66 and 67. Two drawings by J.M. Parramón in sanguine and chalk with highlights in white chalk on colored paper. Above, a study of a plaster head of Seneca.

Fig. 68. Samples of colored paper by Canson mi-Teintes (France), for charcoal, chalk, and pastel drawings.

68

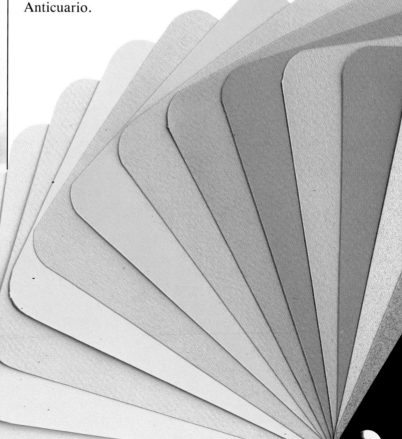

Trademarks for quality drawing paper	
Arches	France
Canson	France
Fabriano	Italy
Grumbacher	United States
R W S	United States
Scholler	Germany
Whatman	England
Guarro	Spain

Basic tools

Drawing lies at the root of all the plastic arts, the sumptuary arts, architecture, decoration, and commercial art. Drawing media range from charcoal to watercolor, including sanguine, colored pencils, pastels, pen, and the basic lead pencil. The paper used can be of low, medium or high quality, white or colored, and it can be supported on a folder or a drawing board, with or without an easel.

But we should remember that just a pencil and a piece of paper resting on a flat surface are all that we really need to draw with; anything else is merely a refinement of the basic materials.

There are several factors which need consideration before we begin to draw. First, we should be reasonably comfortable, and for this reason it is a good idea to draw in a seated position, unless the size or complexity of our subject demands that we work standing up. Secondly, we need a support for our paper. In the studio, this can be an easel, in the mountains or at the sea it can be any large stone, tree stump, or similar object. Remember, too, that special easels that support board and paper together are available. These are foldable paint-box easels, principally designed for painting, but also a practical solution for drawing outdoors.

Fig. 69. The basic materials necessary for drawing are a medium-size folder to carry and support your drawing paper and one or two large metal clips. You can draw sitting on a stool with your folder on your lap or resting on the back of a chair.

Fig. 70. When using a studio easel to draw on, the stool should be far enough back so that you can alternatively lean closer drawing with the stick of the pencil inside your hand, and move far away from your drawing in the typical artist's position with your arm stretched out, without moving your seat.

Fig. 71. Holding the pencil in the way you would to write (A) is useful for outlining and drawing details. To draw the stronger basic lines, outlining and drawing at the same time, a good idea is to hold the stick of the pencil inside the hand (B), and this third way of holding the pencil (C) is ideal for shading and darkening.

69

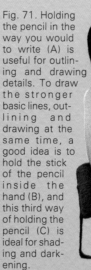

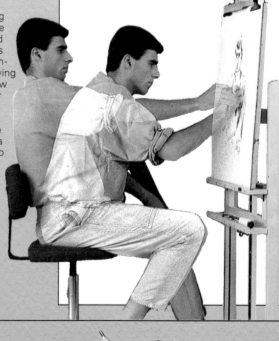

70

71

A B C

Lead pencils, stumps, rubber erasers

The most common drawing instrument is the graphite or plumbago pencil, more commonly known as the lead pencil. Its origins lie in the mines of Cumberland in the north of England, where graphite was discovered in 1560. It was not brought to the Continent until 1640. In 1792, the engineer and chemist Jacques Conté perfected the method of making graphite pencils, inventing a lead combining this material with clay and covering it with cedar wood. His method led to production of soft or hard lead pencils, to allow artists to make a lighter or darker impression on the paper.

Today, manufacturers can offer a wide range of qualities and gradations of leads. These are:

1. High-quality pencils in nineteen gradations (fig. 75) indicated by a B (soft) for artistic drawing or an H (hard) for technical drawing. The gradations HB and F are neutral.

2. Pencils suitable for use in schools, with four gradations, no. 1, the equivalent of a 2B, no. 2, the equivalent of a B, no. 3, the equivalent of an H and no. 4, equivalent to 2H. Numbers 1 and 2 are the most suitable for drawing.

A good selection of lead pencils for drawing would include a number 2 pencil for general use and for light shading, a 2B, a 4B and an 8B for dark black sketches and quick notes, and to reinforce the darker areas of a drawing.

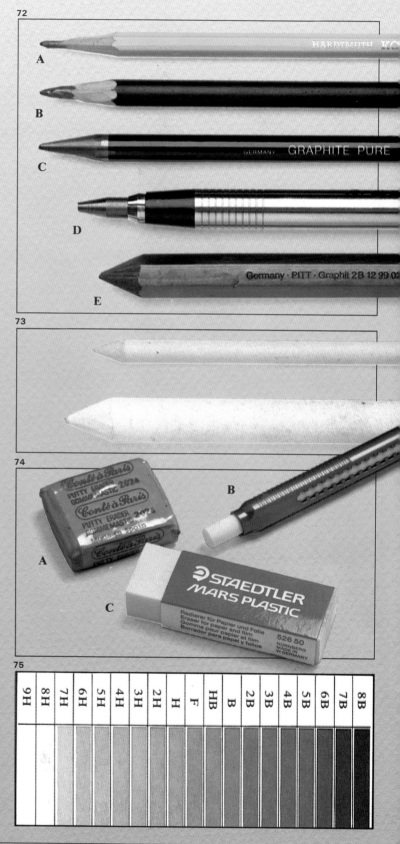

Fig. 72. (A): graphite pencil. (B): soluble graphite pencil. (C): all-graphite pencil. (D): mechanical pencil for soft 5 mm (.2'') lead. (E) graphite stick.

Fig. 73. Stumps of two different sizes.

Fig. 74. Different types of erasers: (A), kneadable, (B), at the top of a mechanical pencil and (C), compact plastic.

Fig. 75. The 19 gradations of high-quality pencils, showing the ranges of soft (B) and hard (H) leads.

9H	8H	7H	6H	5H	4H	3H	2H	H	F	HB	B	2B	3B	4B	5B	6B	7B	8B

Lead pencils, stumps, rubber erasers

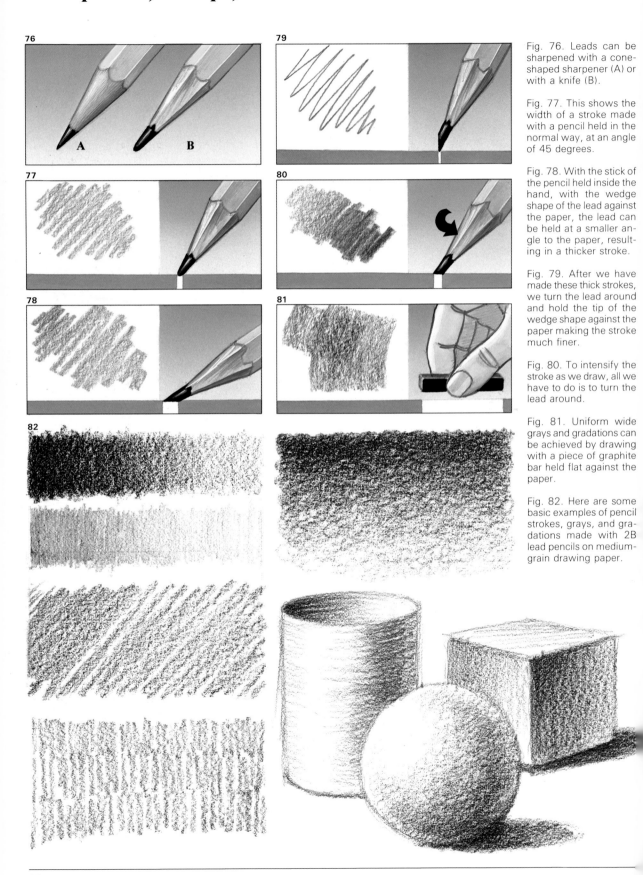

Fig. 76. Leads can be sharpened with a cone-shaped sharpener (A) or with a knife (B).

Fig. 77. This shows the width of a stroke made with a pencil held in the normal way, at an angle of 45 degrees.

Fig. 78. With the stick of the pencil held inside the hand, with the wedge shape of the lead against the paper, the lead can be held at a smaller angle to the paper, resulting in a thicker stroke.

Fig. 79. After we have made these thick strokes, we turn the lead around and hold the tip of the wedge shape against the paper making the stroke much finer.

Fig. 80. To intensify the stroke as we draw, all we have to do is to turn the lead around.

Fig. 81. Uniform wide grays and gradations can be achieved by drawing with a piece of graphite bar held flat against the paper.

Fig. 82. Here are some basic examples of pencil strokes, grays, and gradations made with 2B lead pencils on medium-grain drawing paper.

83

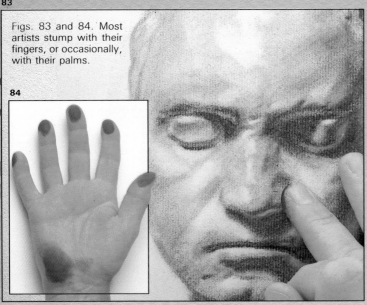

Figs. 83 and 84. Most artists stump with their fingers, or occasionally, with their palms.

84

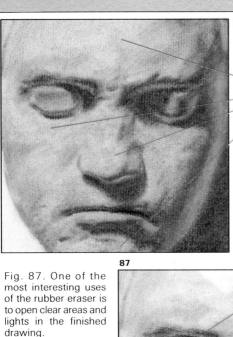

85

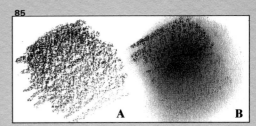

A B

The rubber eraser is an essential tool for drawing, though it should only be used sparingly, as a last resort, as overuse of it will damage the fiber of the paper. There are two basic types of eraser, hard ones made of plastic or rubber, and soft, malleable ones similar to plasticine that can be kneaded into different shapes to erase particular forms.

However, the eraser is not just a tool for rubbing out and correcting mistakes, but can also be used in the actual process of drawing, to draw in shadows and shiny areas, as in a portrait, for example, when you are putting in the shine of the nose, the lower lip or the forehead. (This is demonstrated in the "before and after" illustrations in figs. 86 and 87, the first showing the face of Beethoven stumped, the second with the shadows and shiny areas *drawn* with the kneadable rubber eraser.)

The stump, too, assists in drawing. As you know, the stump is a kind of pencil with two points made of spongy paper. It is used to rub and blend, to gray or degrade lines or areas of a drawing done in lead pencil, charcoal pencil, charcoal, sanguine, chalk, pastel, etc. An artist will generally include two or three stumps of varying thicknesses among his or her materials, using each point to create a different intensity.

Though stumps form a useful part of an artist's equipment, most artists, in fact, blend their work more often with their fingers or, occasionally, their palms (see fig. 84).

86

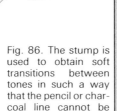

Fig. 86. The stump is used to obtain soft transitions between tones in such a way that the pencil or charcoal line cannot be seen.

Fig. 87. One of the most interesting uses of the rubber eraser is to open clear areas and lights in the finished drawing.

87

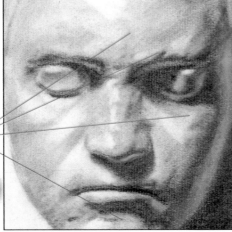

Fig. 85. A gray or gradation drawn with lead pencil (A) takes on greater intensity, becomes darker, when it is blended with the fingers (B), as the oil on the finger and the pressure exerted tone down the roughness of the paper.

Charcoal and its derivatives

The charcoal drawing is one of the old-est known to art. The ancient Greeks used carbonized branches of willow, vine or walnut wood in much the same way as we now use charcoal.

Charcoal and its derivatives are consi-dered the ideal medium for drawing figures from life, for sketching, and for preliminary drawings for oil paintings. It is sold in the shop in the form of sticks 13 to 15 centimeters (5" to 6") in length, with a thickness of 5 to 15 millimeters. Some manufacturers offer a range of three degrees of hardness.

Various derivatives of charcoal are also available. First, there is the charcoal pen-cil (fig. 88), also known as the *Conté crayon* and which, like the charcoal stick, comes in different degrees of hard-ness.

Brand	Extra soft	Soft	Medium	Hard
Conté	3B	2B	B	HB
Faber-Castell "Pitt"	—	Soft	Medium	Hard
Koh-i-noor "Negro"	1 and 2	3 and 4	5	6
Staedler "Carbonit"	4	3	2	1

Another derivative of charcoal is com-pressed natural or artificial charcoal, to which binders are added (as well as, oc-casionally, clay) to increase the intensi-ty of the tone obtained (fig. 88, 1, 3, and 4) and to give it a finish similar to that of a pastel drawing.

Last, there is powdered charcoal, which can be seen in fig. 93. Used with a stump or the fingers, it is ideal for covering large areas.

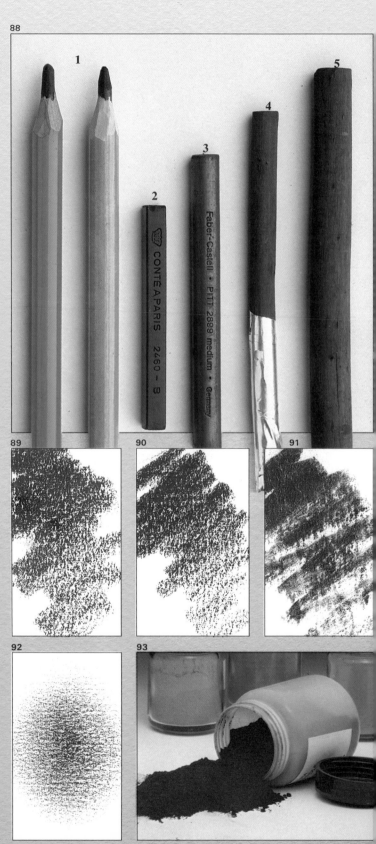

Fig. 88. Charcoal pencils of different gradations: (1), sticks of compressed artificial chalk-plaster, (2), a bar of artificial compressed charcoal, (4 and 5), two sizes of car-bonized willow, vine, or walnut charcoal.

Figs. 89 to 91. The results: fine, precise strokes in the case of the charcoal pencil (fig. 89), rougher strokes in the case of the charcoal stick (fig. 90) and thick, in-tense strokes in that of the compressed charcoal bar (fig. 91).

Figs. 92 and 93. Char-coal powder allows the artist to gradate tones without leaving the mark of lines or pencil strokes. Powdered pigments are also available, in san-guine, green, blue and so on, for use in sanguine or colored chalk drawings.

Basic techniques

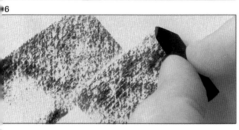

Fig. 94. Although the tip of the charcoal stick quickly loses sharpness, the edge of the point can be used to draw fairly thin lines.

Fig. 95. Drawing with the bevel-shaped tip, the charcoal stick can be used to draw thick lines of various intensities.

Fig. 96. Pressing a small piece of charcoal sideways to the paper, you can obtain wide strokes that help in the task of making grays or gradations.

Charcoal is not the best material to use in work where precision of line and detail are important factors. On the other hand, it is an excellent medium when effects of light and shade are desired, or when modeling a figure through the juxtaposition of areas of different tonal intensity.

Not being a very stable material, charcoal is easy to erase with a rag or a kneadable eraser, and it is also simple to construct grays and gradations in charcoal using a stump or the fingers. The instability of charcoal also makes it essential to use a fixative to ensure that your finished drawing does not become smudged and to give it permanence. Fixative comes in bottles and aerosol sprays. Bottled fixative is sprayed onto the paper through a small tube. Once dry, the liquid forms a fine film on the surface of the paper, protecting the drawing.

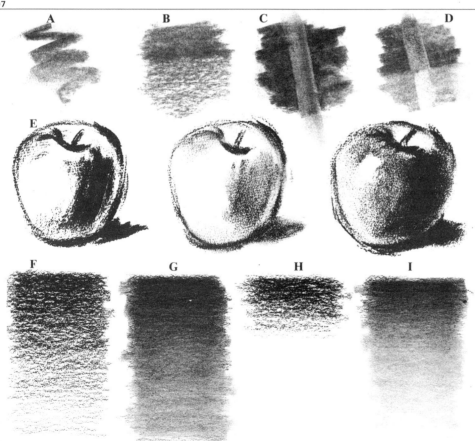

Fig. 97. Charcoal is a rather unstable medium, easily rubbed out with the finger (A) or by blowing hard (B). Just from rubbing lightly with the finger it loses intensity (C), and can be erased, though it will always leave a faint trace (D). But charcoal is a ductile material which "paints" and provides a wide range of tones, as we can appreciate in this apple (E).

The charcoal pencil or bar of compressed charcoal is more stable and "paints" more than does charcoal stick. In (F), we can see a gradation made with charcoal pencil, which, in (G) becomes blacker, losing its gradated form when stumped, so that the size of the gradation should be reduced (H) and then spread over the paper with the stump (I).

Sanguine and chalk

White chalk is obtained from limestone of organic origin, which is then mixed with water and a binder. It is commercially available in bars or sticks. Colored chalks can also be found, made entirely of pigment, in the case of full colors, and of pigment mixed with chalk, in the case of intermediary colors. Some brands of chalk are available in boxes of up to 24 colors. Besides black and white chalk, Faber also produces a special range of twelve colors from ochre to dark siena and another special range of six grays.

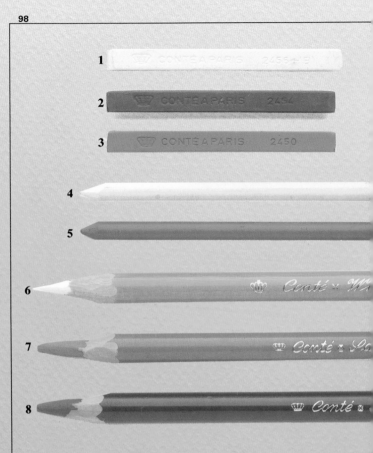

Fig. 98. (From top to bottom): white chalk, dark sepia, and sanguine in bars (1, 2 and 3); Koh-i-noor sticks of white chalk and sanguine (4 and 5)—there is a whole range of Koh-i-noor colors in sticks like these; Conté pencils, white, sepia, and sanguine (6, 7 and 8).

Fig. 99. Two cases of colored chalks and kits for drawing with lead pencil and charcoal. At the bottom of the picture, Faber's special ranges of ochres and sanguines in one box, and of grays, and a selected range of hues in the other.

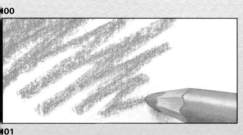

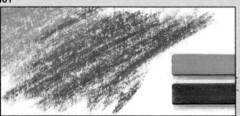

Figs. 100 to 102. With the sanguine pencil it is possible to draw with great precision, putting in small forms and details (100). Bars of sanguine and dark sepia chalk give attractive combinations of color (101), but this combination offers its best results when used on colored paper and with highlights in white chalk (102).

Figs. 103 and 104. Miquel Ferrón demonstrates two examples of the *dessin à trois crayons* on cream and gray mi-Teintes paper.

Sanguine is made of iron oxide, chalk powder and a binder. Its name comes from its characteristic reddish color. White chalk, sanguine, dark sepia and such other typical chalk colors as ultramarine and olive green come both in the form of pencils and in 5 cm (2'') bars.

One of the most effective methods used by the artists of the Renaissance was that of drawing with sanguine or sepia or black charcoal on colored paper, then heightening shadows and shiny areas with white chalk.

Rubens, Jordaens and others in the seventeenth century and Boucher, Fragonard and Watteau in the eighteenth century all used this technique frequently in their work. The French called it *dessin à trois crayons*.

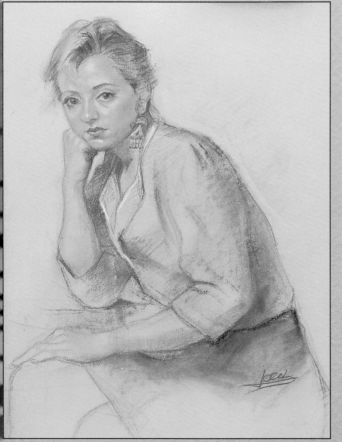

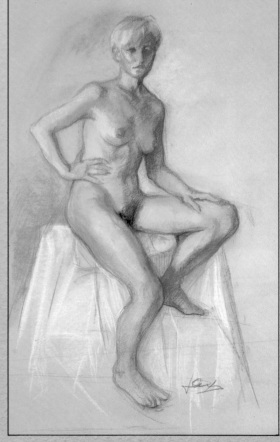

Pens, canes, and brushes

India ink is black. You can buy it in solid form (in bars) or in liquid form (in bottles). Bars of ink, soluble in water, are used for wash drawings (made with a brush); liquid ink can be used either with a brush or with a cane or nib. Ink is also available in different colors.

The Perry metallic nib is the one most often used in ink drawing. It can be joined to a wooden handle and is interchangeable with other nibs. The Osmiroid fountain pen is easier to handle than the nib, as it contains an ink cartridge.

The best brushes for ink are made of sable or mongoose hair, numbers 3 to 6. To produce rubbing effects, a sow-hair brush, rather harder than the first two, is recommended, and for softer washes, a Japaneses Sumi-e brush.

As its name indicates, the cane is a piece of dry cane, cut into a beveled shape at one end, where a slit is made, as if it were a metal pen nib. The thickness of the line drawn by this instrument varies according to the size of the slit, but it is generally rather broad. To draw, you load the cane with just a small amount of ink, then rub it on the paper to achieve grays of a quality which cannot be obtained any other way.

Last, to draw uniform lines of a precise thickness, you can use a fountain pen. This pen has its own supply of ink, and its nib can be changed.

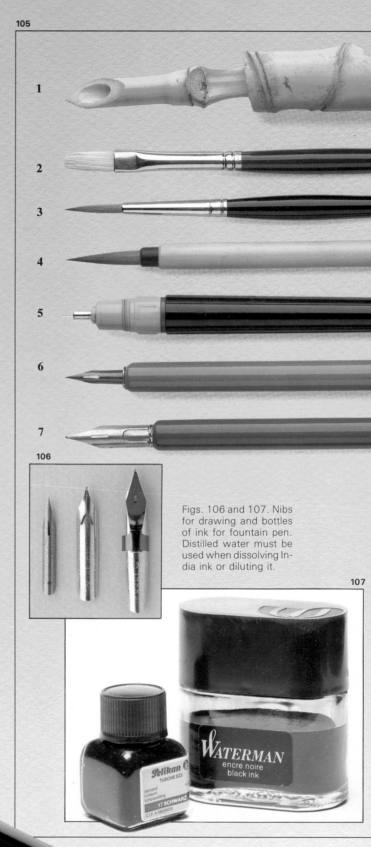

105

1
2
3
4
5
6
7

106

107

Fig. 105. Various instruments for working in pen and ink: (from top to bottom), cane; sow-hair, sable-hair and deer-hair paintbrushes—this last a special Japanese brush for painting in the Sumi-e technique; fountain pen; metal Perry nib with handle; and Osmiroid fountain pen.

Figs. 106 and 107. Nibs for drawing and bottles of ink for fountain pen. Distilled water must be used when dissolving India ink or diluting it.

108

109

110

111

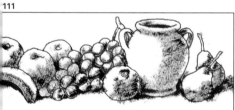

Figs. 108 and 109. The nib and handle should be held in normal position to draw fine or medium lines (108), but for a thicker impression, the pen should be held at a greater angle (109).

Fig. 110. Results like this are obtained by first drawing with pencil, then making a pattern of parallel lines, each of identical thickness, with the Rotring. With a metal nib, shade by thickening the lines according to the intensity of the shadow.

Fig. 111. A metal nib has been used in this drawing to outline the profiles, and a dry brush for the shaded areas on fine- or medium-grain paper.

Fig. 112. Miquel Ferrón drew these nudes with a fountain pen.

Figs. 113 and 114. (Left): I produced this drawing with cane and India ink diluted with distilled water. (Right): This pen-and-ink drawing was made on coarse-grain paper and finished with India ink and brush.

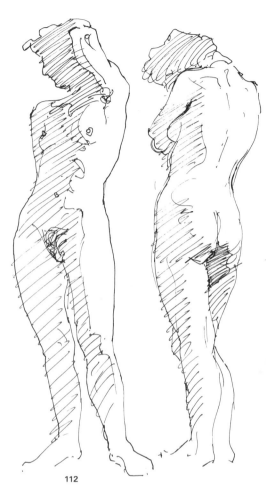

112

113

114

Colored pencils

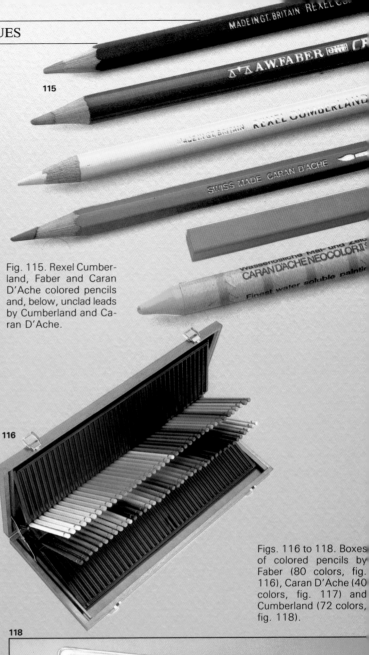

It may surprise you to learn that great artists like Gustav Klimt and David Hockney have drawn and painted much-admired pictures with colored pencils. But it is true. Colored pencils can be used to produce works of a quality equal to that of any other medium for drawing or painting. And colored pencil drawings have the advantage, from the point of view of someone just starting out, of being the ideal medium to begin to learn about the selection, composition and mixing of colors. For the beginner this is not a strange, unknown technique, as the brush, the cane, or the palette knife might be, a difficult medium like watercolor or oil painting, in which pigments must be mixed with water or oil, and that demand a certain know-how. With watercolor, for example, you have to know how much water and how much red you need on your brush to obtain pink. Or, when you paint in oil, the quantity and thickness of the ochre to put on so that, mixed with ultramarine, a little carmine, and white you can achieve a warm gray tone. Mark my words, this is no exaggeration! These problems exist in painting with watercolor, with acrylic paints, with pastels, with oil.
With colored pencils though...

Fig. 115. Rexel Cumberland, Faber and Caran D'Ache colored pencils and, below, unclad leads by Cumberland and Caran D'Ache.

Figs. 116 to 118. Boxes of colored pencils by Faber (80 colors, fig. 116), Caran D'Ache (40 colors, fig. 117) and Cumberland (72 colors, fig. 118).

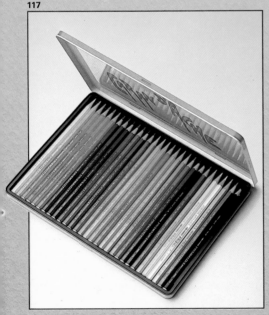

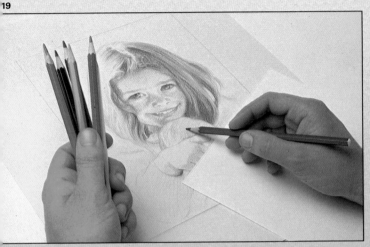

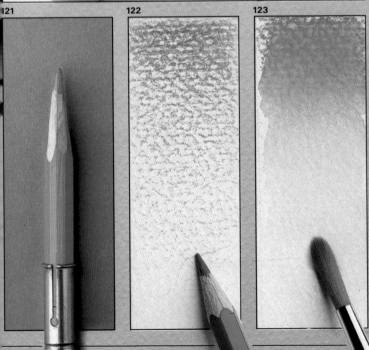

You may want to paint the leaves of a plant or a tree with a sap green. Well, you just take up your sap green colored pencil and paint. But then you notice that there is a yellowish reflection of the light on one of the leaves of your model. Fine, you paint lightly in sap green, then go over it with your ochre pencil, mixing the two colors step by step you build up color. You add more green, more ochre, more green, a little blue—and all the time *you control* the color, the tone. This is the big difference:

When you paint with colored pencils, use the color you want, always building up color from less to more, controlling the color yourself.

There are no tricks or mysteries. The simple fact is that when you paint with colored pencils, you have a box of thirty, or seventy-two, or even eighty different colors! These colors might include sap green, permanent green, emerald green, hooker's green and so on, up to a total of ten different greens. You do not have to run the risk, as you do with watercolor or oil, of mixing a green, painting with it then changing your mind and having to correct the color if you can. With colored pencils, you just build up colors little by little, using *a pencil*, a medium you know, that you have already mastered.

Figs. 119 and 120. While drawing with one of these pencils, it is a good idea to hold the rest of the pencils of the same range, or those you use most, in the other hand. Keep a container handy to keep the colors you are using most frequently while you work on a particular piece.

Fig. 121. Use pencil holders to hold very short pencils to get maximum use out of them; when they get very small, they are difficult to hold normally.

Figs. 122 and 123. An example of the quality of water-soluble pencils: on the left, a gradation made with a medium-blue pencil on dry coarse-grain watercolor paper, and on the right, the same gradation dissolved with a wet brush.

Colored pencils

Fig. 124. Colors are mixed by adding different layers and through transparency, though, with the ranges of 40 or more colors available, it is usually possible to find the color you want without mixing.

Fig. 125. If you paint a blue patch and paint over it in yellow, you will get a light green (A). If you change the order and paint blue over a yellow patch, you will get a darker, bluer green (B).

Figs. 126 and 127. The preliminary drawing of a theme in colored pencils must be made in a particular color depending on the subject. You should not use a lead pencil, as this will make your colors dirty.

Figs. 128 and 129. The technique of painting with colored pencils involves painting ''from less to more,'' taking care over shades and colors.

Figs. 130 and 131. You paint the model normally (A), then use the white pencil to paint over your picture (B), thus achieving results reminiscent of a pastel painting.

Figs. 132 and 133. The colors of the spectrum in fig. 132 were painted using just three colors, yellow, carmine and medium blue, the three primary colors. Fig. 133 was produced with twelve different colors, and, although the difference is minimal, there is a greater richness of color in the second.

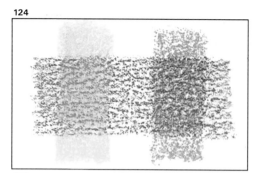
124

125

126

127

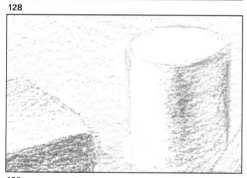
128

129

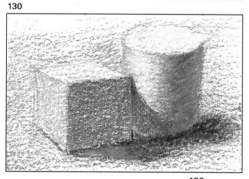
130

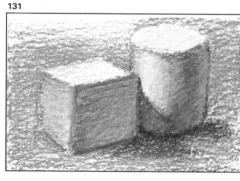
131

132

133

Let's take a look at the features, classes, and qualities of colored pencils. The stick, or lead, of these pencils is made of colored pigment bound with wax and varnish and protected by a wood covering. There are pencils whose quality makes them desirable for use in schools (in simple boxes of twelve), and high-quality pencils available in boxes of twelve, twenty-four, thirty-six, forty, sixty, seventy-two, or eighty different colors. Caran D'Ache supplies boxes of forty colored pencils with two gradations, the Prismalo I selection containing pencils of ordinary hardness, and the Prismalo II soft pencils. Rexel Cumberland supplies a box of seventy-two colored pencils, while Faber-Castell has a box of sixty, and a splendid case with a selection of eighty different colored pencils. Most manufacturers now produce both water-resistant and water-soluble pencils and all sell replacement pencils separately. Note the new lines of square leads supplied by Cumberland and the cylindrical leads produced by Caran D'Ache in figs. 115 and 118 on page 40. These leads are not wood-clad.

Figs. 134 and 135. Two examples of the possibilities of colored pencils as an artistic medium. The mountain landscape was done on gray Canson mi-Teintes paper. Note that the gray of the paper is visible in several places, and that the color of the paper and the blues and greens of the picture are decisive in the harmony of this range of cold colors. *The Church of St.-Germain-des-Prés, Paris*, painted in water-soluble pencils. Notice how only parts of the picture have been painted over with the wet brush. This effect is combined with the visible strokes of colored pencil and with watercolor added at the end.

A modern technique: markers

The marker is the most recent invention of all the media and techniques explained in this book. It was created in Japan in the 1960s and is a kind of felt-tip pen with a reservoir inside formed by wadding to hold the ink. The felt tip is made of porous polyester and the ink flows to it through a myriad of tiny holes. The ink used is composed of pigment and a solution similar to alcohol called xylene. (Water-based markers without xylene, suitable for children, are also available.) Markers are available in three different thicknesses of tip. These are: broad-tip, to cover large areas of color quickly and easily; medium-tip, for drawing details, and fine-tip, for drawing outlines and painting pen-and-ink-type drawings.

There are five major brands of markers. Two series of these are outstanding: the American Pantone by Letraset, with 203 broad-tip colors and 223 fine-tip colors, and the English Magic Markers with a range of 123 colors.

Special "marker" or "feutre" paper is made for drawing with markers. If you cannot find any, very satiny paper, such as Bristol card will do. "Couché" paper is not suitable.

When a marker is new and the ink flows easily, a uniform continuous line can be achieved, and wide, flat areas of color can be painted without any line being noticeable. Colorless markers, ideal for blending colors, painting grays and gradations, and so on are also available.

Note the three ways of drawing with a broad-tip marker demonstrated in fig. 137: first using the edge of the tip for fine lines, second with the thinner side of the tip for a medium line, and third inclining the marker to make contact with the whole of the top side for a thick line.

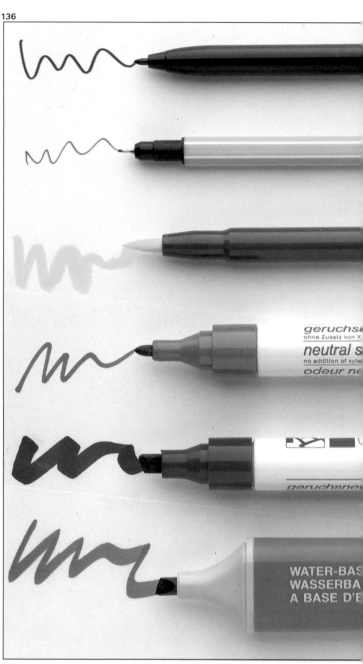

136

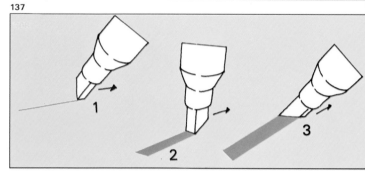

137

138

139

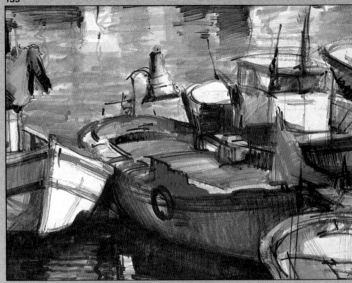

140

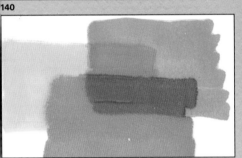

141

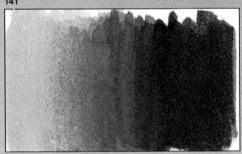

Fig. 138. Claude de Seynes. *Portrait of Alicia*. De Seynes, a French artist specializing in markers, offers here an example of painting with planes of uniform colors, juxtaposing broad strokes one next to the other with perfect blending.

Fig. 139. Miquel Ferrón. *Boats in a Port*. A fine demonstration of the pictorial and artistic qualities that can be obtained with markers.

Fig. 140. The ink of the marker is transparent, and new colors can be obtained by superimposing one color over another.

142

143

Fig. 141. Gradations like this can be produced with the help of the neutral marker or by blending two or more colors.

Fig. 142 and 143. With markers, it is always important to paint from less to more. As in watercolor, the colors are transparent, and it is not possible to paint a light color over a dark.

144

145

Figs. 144 and 145. One color applied in successive layers becomes darker, as we can see in these illustrations.

Wash, the first step in watercolor painting

A wash drawing is a monochrome watercolor; that is to say, it is painted in just one color, usually black. Sometimes a second color is used—sepia, blue, or green. Many artists have painted studies and definitive works in wash, from Leonardo and Raphael, Rubens, Rembrandt, Lorrain, Constable, Goya, Delacroix and Monet to Van Gogh and Picasso.

Most often watercolor paints are used for wash, but you can also use black or sepia India ink diluted with distilled water. You can see the materials you need to paint in wash at the bottom of this page. Notice that they are practically the same as for painting in watercolor: water, brushes of various sizes, a sponge and paper towel, white wax (for reserving areas), and such auxiliary materials as a jar of water, a drawing pencil, some cotton swabs (to absorb paint), drawing pins, tape and paper clips.

Wash is the first step in watercolor painting. Because it is a monochrome technique, there is no need to compose or mix colors, and color harmony is not a problem. When you are painting in wash, you have only to worry about drawing and the techniques for painting a gray or a gradation, opening a white, and so on.

I recommend that you carry out the practice exercises shown here, painting over

146

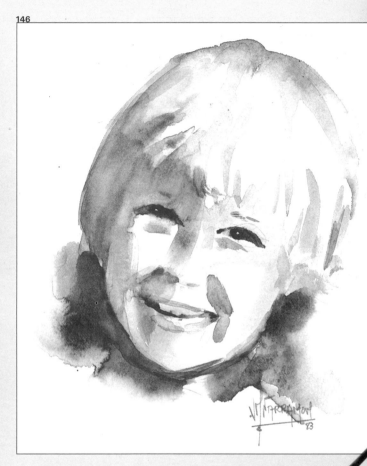

Fig. 146. I painted this head of a child in wash with black watercolor.

Fig. 147. Materials and tools for painting in wash, nearly the same as for painting in watercolor.

147

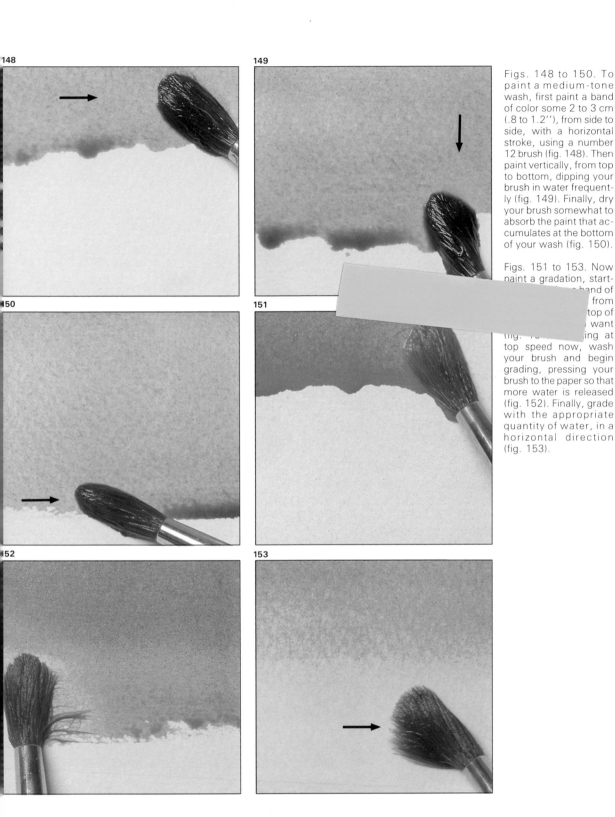

Figs. 148 to 150. To paint a medium-tone wash, first paint a band of color some 2 to 3 cm (.8 to 1.2''), from side to side, with a horizontal stroke, using a number 12 brush (fig. 148). Then paint vertically, from top to bottom, dipping your brush in water frequently (fig. 149). Finally, dry your brush somewhat to absorb the paint that accumulates at the bottom of your wash (fig. 150).

Figs. 151 to 153. Now paint a gradation, start- ———— band of ———— from ———— top of ———— want (fig. ———— ing at top speed now, wash your brush and begin grading, pressing your brush to the paper so that more water is released (fig. 152). Finally, grade with the appropriate quantity of water, in a horizontal direction (fig. 153).

an area about 12 cm (5'') wide by 15 cm 6'') high, using coarse-grain watercolor paper and a sable-hair number 12 brush. Do not despair if your work does not come right at first. You will probably have to repeat the exercise at least three times before you are happy with the results.

Wax crayons

Wax crayon is one of the oldest media in the history of art. In ancient Egypt, Greece, and Rome the technique, known then as encaustic, was known and practiced. Nowadays, wax crayons come in wide ranges of up to 64 colors. There is also a derivative of crayon known as oil pastel, with basically the same characteristics as wax crayon, except that wax is generally softer and greasier providing greater plasticity. Wax crayon is more impermeable than oil pastel, and when we paint one layer of it over another, the wax becomes smooth, eliminating the grain. The colors do not stay fast, and it is difficult to paint a lighter color over a darker one. Oil pastels are softer, allowing you to paint light over dark in the same way as with real pastels.

Apart from this small difference, the possibilities and techniques of both media are nearly the same.

Both are applied by rubbing and can be stumped and blended with the fingers. Both are difficult to erase. When you want to, you have to remove the layer of wax or grease by scratching it off with a cutter or knife, and then use a plastic eraser. Scratching with the knife removes the wax from the grain of the paper so that it is possible to paint over again with no difficulty. When a darker layer is painted over a lighter one, you can scratch the darker layer away with a knife to allow the lighter layer to show through.

Finally, both media dissolve in oil of turpentine, allowing you to make grays and gradations with the paintbrush in a style we could call wax wash.

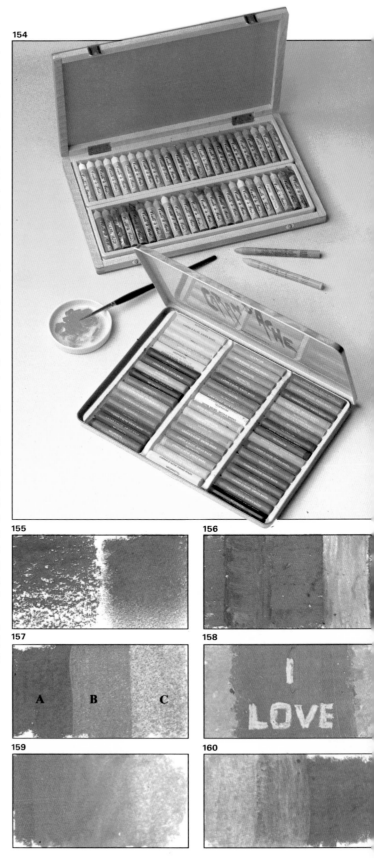

154

155

156

157

A B C

158

159

160

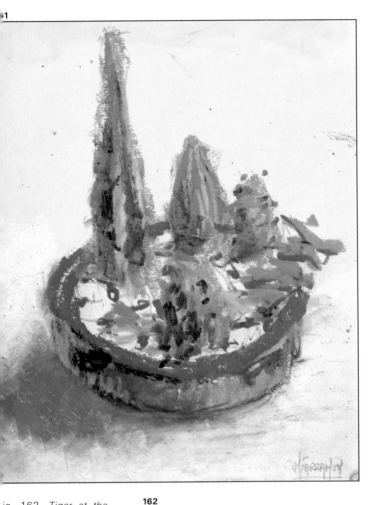

Fig. 154. Shown here are *Conté à Paris*, a box of 48 different pastel colors, and, below, the Caran D'Ache box of 48 wax crayons. Next to that is a pot with wax color dissolved in oil of turpentine.

Fig. 155. Wax crayons and oil pastels are applied by rubbing (left) and can be stumped with the fingers (right).

Fig. 156. Wax crayons and oil pastels are colors that cover totally, so that you can paint one color over another, even white over carmine, as shown here.

Fig. 157. It is not easy to erase these colors with a rubber eraser. Here, I painted in carmine (A), took off the layer with a razor (B) and erased what was left as best I could. All the color cannot be removed.

Fig. 158. If you paint a light background (in this case, yellow), paint a darker color over it (carmine, here), then scratch with a razor, the result will be a form seen as if it were a photographic negative.

Fig. 159. Wax crayons, like oil pastels, can be dissolved in oil of turpentine, as has been done in this gradation.

Fig. 160. If you dissolve some color in oil of turpentine and paint this diluted color over light or dark areas, you will obtain glazed effects similar to those shown here.

Fig. 161. *Container with Cactus*, painted in wax colors. Notice how the vertical strokes of light green have been achieved by scratching with a razor blade.

ig. 162. *Tiger at the 'oo*, painted in wax olors by Vicente Balles-ar, a master of the art of ainting animals in any nedium. Notice here the chness of color and the se of gray, strokework nd stumping. You can ee how the artist has sed a razor to open mall whites, in the vhiskers, the ears, the nigh, and so on.

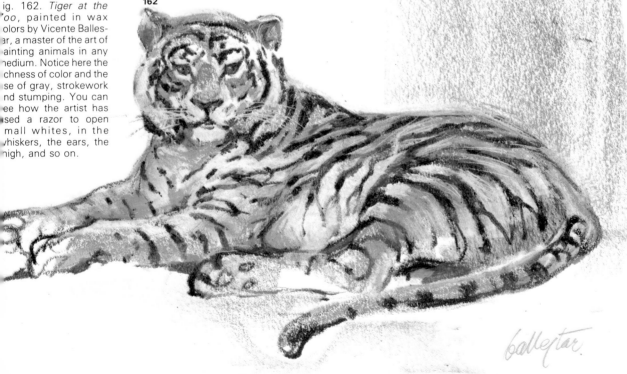

The magic of pastel colors

Just what is a picture painted in pastel colors— a drawing or a painting? Some say that it is a drawing, reminding us that Degas drew more than painted his women getting out of the bath or his ballerinas in their flimsy tutus, others maintain that it is painting, citing the work of Chardin, Quentin de la Tour or Rosalba Carriera.

In any case, what is certain is that pastel is a ductile, fine, malleable material that blends and adheres to the paper as if by magic and is available in an enormous range of colors. The American brand Grumbacher offers a splendid case containing 336 different colors, Talens' Rembrandt selection has 180, Schminker 99, Faber 72, and so on. You can also buy pastels in the form of pencils. Why so many colors, and what for?

Because of its purity, pastel is a weak material. Its composition does not include oils or varnish, only pigments and powder bound with water and gum. So it is fragile, prone to disintegrating, unstable. And that is why *when painting in pastel, the artist only mixes colors to adjust tones, painting his colors directly onto the paper and therefore needing a wide range of different colors.*

Now make a note of the following facts: Pastel colors cover entirely; the artist can paint light colors over dark. The fingers can be used for blending but the paper stump will not mix colors. The paper has to be either coarse- or medium-grain, depending on the size of the picture. (*Canson mi-teintes* paper has two sides, one medium-grain, the other coarse-grain.) Pastel rubs off well with a kneadable eraser or with just a clean rag. Liquid fixative alters pastel colors considerably so Talens recommends that you fix lightly, later retouching the most affected colors and framing with glass, isolating the drawing from it with a *passe-partout*.

Fig. 163. Boxes of pastels made by Faber-Castell, Rembrandt, and Schminker. At the top of the picture, there is a small box to hold pieces of pastel crayons, very useful when painting with this technique, and at the bottom, pencils, a rag, a fan-shaped brush for cleaning and blending, and a kneadable rubber eraser.

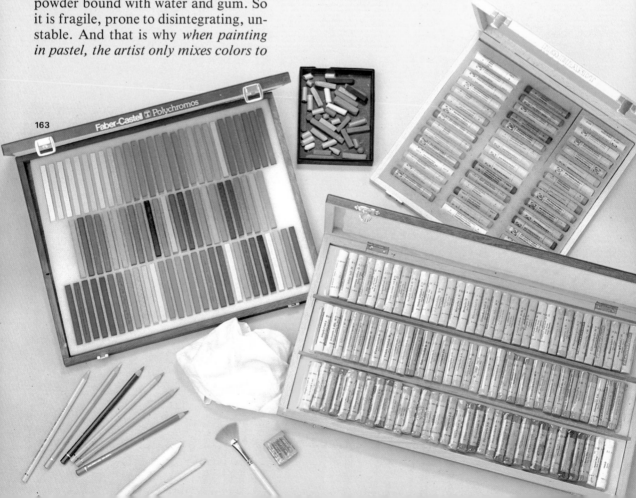

Figs. 164 to 168. A way of shading and grading is to use small pieces of pastel held flat against the paper (fig. 164). Pastels cover, and light colors can be painted over dark colors (fig. 165). In the next illustration (fig. 166), we can see an intense patch rubbed out with a rag. The kneadable eraser can be molded into shapes like this (fig. 167) to draw as you erase. The ductile nature of pastel allows for perfect blending and transitions in colors (fig. 168).

Figs. 169 and 170. Two remarkable examples of drawings painted in pastel by two artists, who were specialists in this medium. On the left, *Feminine Figure*, by José Luis Fuentetaja, and on the right, *Bullfighter*, by Juan Martí.

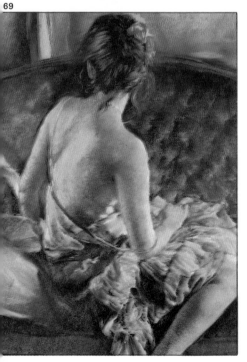

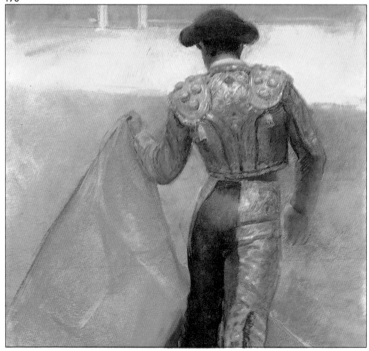

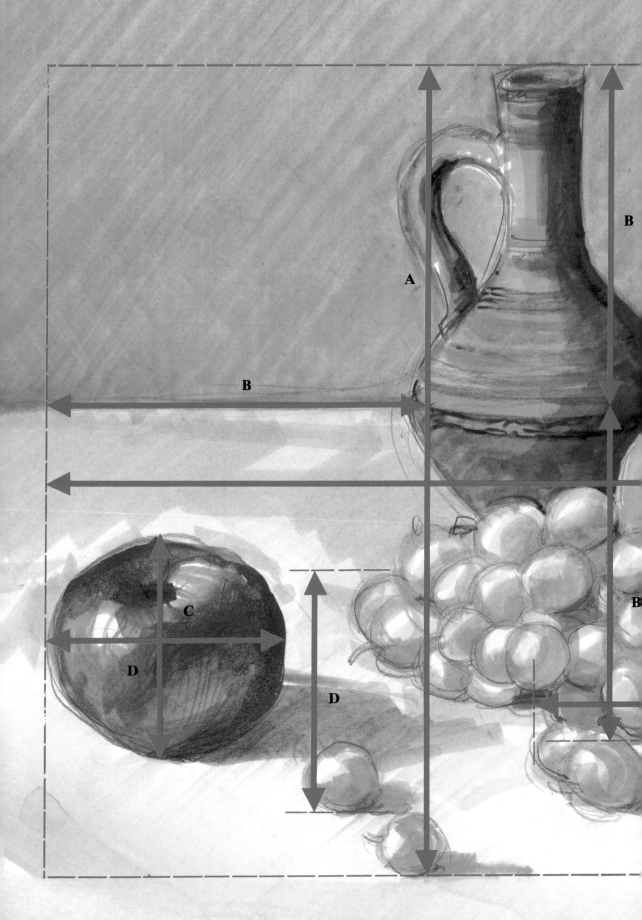

This is the most important section of this book. If you study and learn the contents of this chapter, you will have taken a great step forward in the mastery of the basic techniques of the art of drawing. For, in these pages, we shall discuss, study and put into practice the theory of selection and composition of the subject, the problem of dimensions and proportions, framing, perspective, value, the effects of light and shade, contrast and atmosphere. But, remember, just reading the text and looking at the illustrations is not enough to guarantee success; you must also draw. Complete the practice exercises I suggest by following the instructions. As you read the following pages imagine that I am at your side explaining to you how to draw like an expert. Shall we begin?

Practicing basic drawing techniques

Selection and composition of the subject

Go into the kitchen and get a few pieces of fruit and a jug or another china or pottery container. In the photograph, you can see the subject I have chosen, but it could just as well have been a tomato, a couple of onions and heads of garlic, some asparagus, a glass of wine, and an ordinary bottle.
It is up to you. Any simple model composed of four or five elements will do.

Fig. 172. There are no absolute rules concerning composition, but it is worth bearing in mind the norm established by the philosopher Plato when he declared that *to compose is finding unity within variety*.

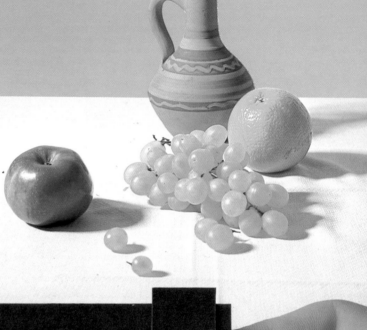

172

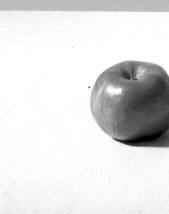

Fig. 173. A frame made of two right-angled pieces of black carboard can be used to determine the overall shape of a picture, the position of the subject in the picture, and the size of the drawing with respect to the size of the paper.

173

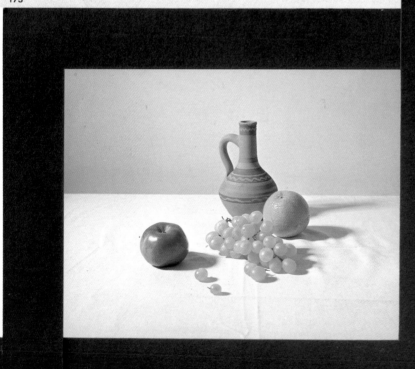

Choose a table near to a window so that the daylight shines onto it from the side, i.e., with *side lighting*, cover it with a white cloth, and lay out your subject. You may also use artificial lighting on your subject. The contrasts may be sharper, but that will not matter.

Now try to compose your subject, to give it an aesthetically pleasing form or appearance. Plato, the Greek philosopher, stated this rule, which, though open to interpretation, is still a valuable piece of advice:

To compose is to find unity within variety

That is, the art of composition consists of placing the elements of the subject so that they are neither too closely grouped together nor too dispersed over your picture space. In my subject (fig. 172) a balance between *unity* and *variety*, I believe, is struck. I think that, if I had placed the apple further to the left, the composition would lack unity, and that the same thing would have happened if I moved the orange further away from the jug. Take your time. Remember that

Cézanne spent hours over the composition of his still lifes, moving the fruit and other elements around.

When you feel that you have found a good composition, frame your picture, bearing in mind that

Framing is composing

Here, you can try out the classical method of observing the model through a black cardboard frame. This frame, made up of two right-angled pieces of cardboard (fig. 173) helps you to decide the following points: A): the overall shape of the picture: whether it should be more or less oblong, vertical, square, etc. B): the position of your drawing within the space of the picture, in the center, higher, or lower, etc. C): the dimensions of the drawing with respect to the size of the paper. When tackling this last point, beware of falling into the typical beginner's error, putting a small drawing into a large picture (fig. 173). Do not be afraid; get in closer to find the best composition! You can see the correct composition.

Fig. 174. Note that, in fig. 173, the subject is made smaller by the distancing of the frame, while in this figure the proportions of the subject are correct in relation to the size of the picture.

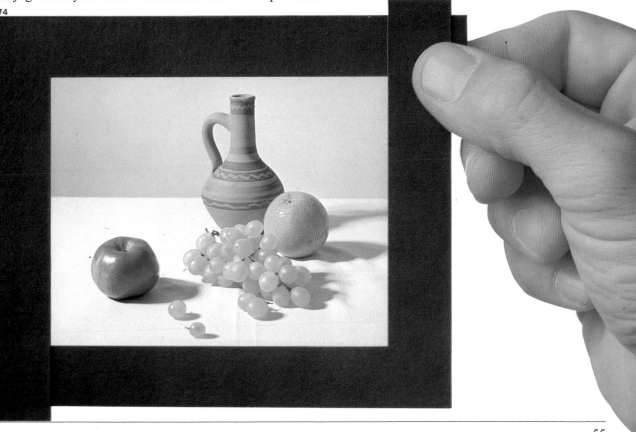

Mental calculation of dimensions and proportions

175

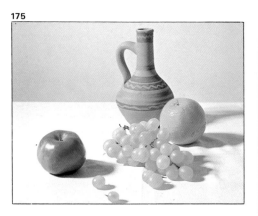

Now we are going to draw, you with your subject, me with mine. You will need a drawing board, an HB lead pencil (for the moment), a kneadable rubber eraser and some 35×25 cm (14×10") medium-grain drawing paper. Step one: observe the subject. Look at it, study it. "Drawing is observing," said Picasso. So observe the forms, the colors, the contrast... and, still without starting to draw, *mentally calculate the dimensions and proportions of your subject.* What is the overall shape? Where is the center of the picture? In my subject, the overall shape is triangular, the vertical center lies a little to the left of the jug, while the horizontal center is almost in the center of the orange, as you can see in fig. 179 on the following page. How high and how wide is the subject? Here, it would be a good idea to tell you a little bit about how the professional artist sometimes measures a subject. The artist takes a pencil or paintbrush (fig. 176) and holds it in front of him as he looks at the subject (fig. 177), raising or lowering his thumb to take one particular size precisely. Then he looks for this same measurement in another section of the model (fig. 178). In this example, I saw that the distance between the top of the jug and the bottom of the grapes is the same as the distance between the outer edges of the apple and the orange (figs. 178 and 180). Now look at your subject, observing, calculating.

176

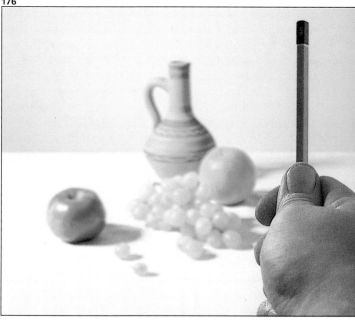

177

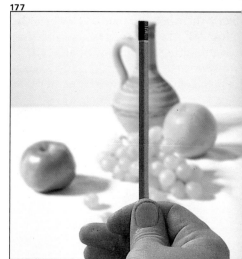

178

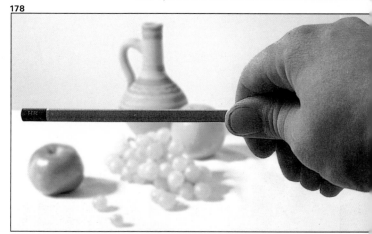

Figs. 175 to 178. The subject (fig. 175) and the three steps of the traditional method for calculating dimension and proportion: Take a pencil or a long-handled brush and place it between you and the subject (fig. 176). Slide your thumb along the pencil until the exposed length of the pencil is the same as that of the section of the subject you have chosen (fig. 177). Finally, if possible, find other sections about the same size in your model (fig. 178).

Using your pencil to measure, or calculating dimensions in your head, you will see that a number of distances occur more than once in your subject. Through discovery of these, you can work out the relative dimensions and situations of each element with respect to others. For instance, in my subject, I can see that the height of the jug (A) is the same as the width of the jug plus the orange (A) and that the diameter of the apple (B) is equal to that of the orange (B), and so on. Give yourself a quarter of an hour or more for this stage of looking at the subject. It will not be time wasted, for, besides calculating dimensions and proportions, you also have the chance to memorize forms, effects of light and shade and contrasts. Even more important, you will begin to interpret the subject in your mind, imagining how *your* drawing (or painting) will look. Now let's begin to draw.

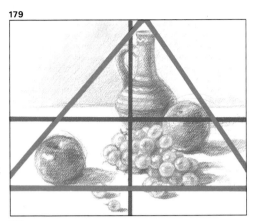

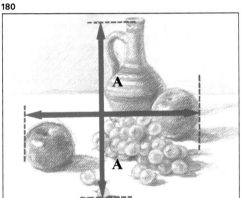

Fig. 179. To center and place your drawing within the space of the picture, use a pencil to calculate the vertical and horizontal centers and draw an overall diagram of the subject—in this case a triangle.

Figs. 180 and 181. Working out dimensions and proportions in your head consists basically of comparing distances, noticing the many sizes that come up again and again in your model.

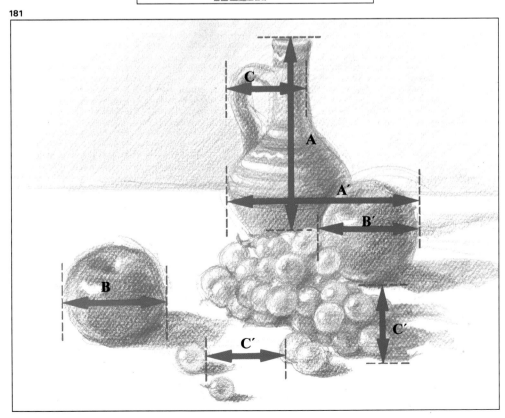

Framing: the problem of three dimensions

182

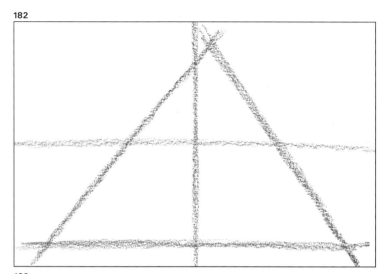

183

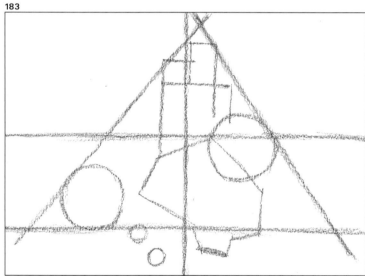

184

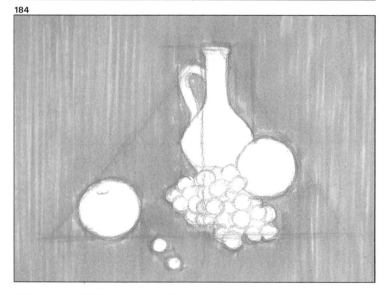

You are going to draw from life, using a real subject. Your subject has three dimensions: height, width and depth, but your drawing will have only two, height and width. This poses a problem.

How do you reduce to two dimensions what you see in three?

It is quite clear, is it not? Like me and everybody else, you have always seen the bodily substance of all objects, their corporality. Your mind is used to placing parts of an object further back in space compared to those in the foreground, to see relief, depth and, in effect, the air that comes between one body and another.

Of course it is easier to copy from a flat surface, as the forms on it are flat, and you can measure everything on it in terms of height and width, merely transferring these measurements onto your paper to achieve the same results.

But what can we do to overcome this barrier of the three dimensions?

First, we have to draw from life over and over again, to get used to seeing the subject as a flat object, without relief, foreshortening or depth. We have to form this habit. I suggest that you *begin by drawing bodies from life that have little relief.* It is easier to draw a face in profile than from the front. (Seen from the front, the nose offers lights and shades in the form of patches.)

Second, try to see the subject as an unknown body.

And, last, *use framing.* To put this another way, *define the structure of the subject geometrically.* This can be achieved by using flat, depthless *frame* in geometric shapes.

Begin your drawing by dividing up the paper or space of the picture with a cross. I have drawn this cross (fig. 182) and have seen by using the method of measuring with my pencil that neither the jug nor the edge of the tablecloth are in the center of my picture.

Figs. 182 to 184. To solve the problem of reducing what we see in three dimensions to a two-dimensional picture, first try to see your model as an object unknown to you. Then work out the structure, beginning by making a plan (fig. 182). Then "box" the different elements of your picture (fig. 183), taking into account above all the "countermold," the parts or forms that make up the background (fig. 184).

Now I draw a plan representing the overall form of the subject. I get a triangle this way (fig. 182). Now I enclose the shapes of the elements in frames, using more or less geometric forms. You can see the results I obtain in fig. 183. Finally, I adjust my drawing, bearing in mind the countermold (shaded, in fig. 184). That is, I consider the shapes and sizes which stand out against the objects of the subject as if I were looking at a negative photograph of the subject.

To make the definitive drawing of the subject, bear in mind the possibility of finding *reference points* connecting vertical and horizontal lines between forms, edges, points, etc. This technique can be of great help in drawing and can be used with any subject (see fig. 185 and 186).

85

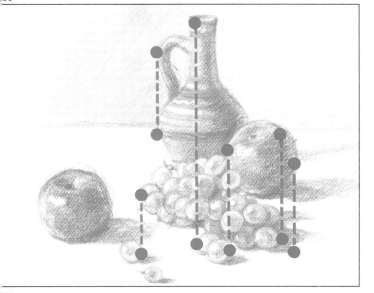

86

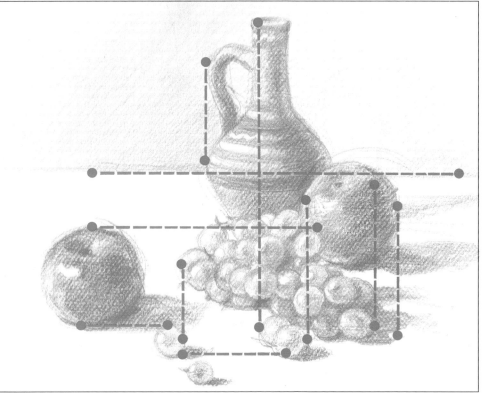

Figs. 185 and 186. It is always possible to find various reference points that coincide vertically or horizontally and that determine the size, situation, level and so on of different forms with respect to others.

Drawing a still life

I will draw my subject; you draw yours. I am going to draw with an ordinary HB pencil, ideal for framing and sketching, one that leaves a fairly light line that can easily be erased.

I draw the pottery jug. It has a symmetrical shape. I draw a vertical line as the center, then the shape of both sides, then the handle and the circular borders that decorate the neck and body. I do all this with light strokes, faintly sketching reference points. Almost at the same time, I make a first approach to the effects of light and shade (fig. 187). This is an important point. Please note that:

> *Bodies are not distinguished as lines or profiles but as color areas of light and shade.*

In your subject, you do not see forms standing out because of their profiles. You and I and everyone see colors, lights and shades of an intensity and form that allow us to recognize the shapes of the objects. So you can begin by drawing "the basket of form," as Ingres called the profile or outline of objects. But *immediately, you must model your drawing.* You must follow Corot's advice when he said, "When painting or drawing, the first thing is value—the effects of light and shade."

We continue drawing, going through the same process of first sketching in the basic lines then constructing lights and shades.

Now we come to an element which deserves separate mention—the bunch of grapes. This is an element that needs to be structured and built up with special care if we are not to lose and confuse its identity. I have to draw this element grape by grape, with be light, shade and shine corresponding to what I see, and with the vine shoots and spaces between one grape and another (fig. 188). It is not a question of getting caught up in detail—"Details are chatterers that have to be kept in line," said Ingres, but neither should we take too little care.

> *Take care over the direction of your pencil strokes.*

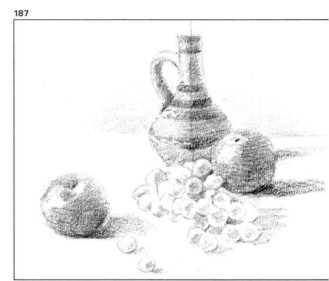

187

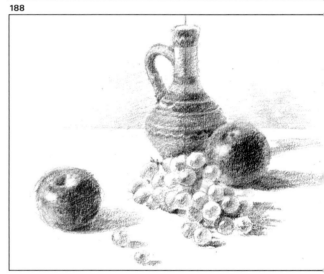

188

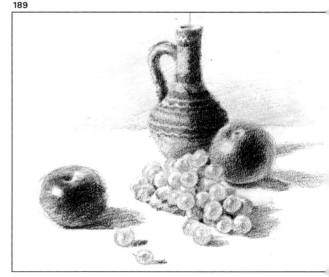

189

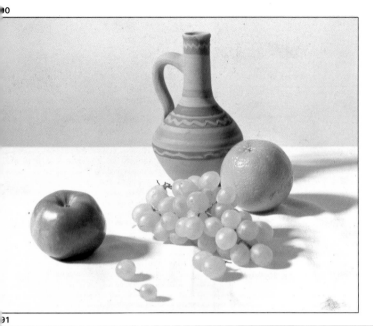

The line must express the form. This means that we are drawing the sea the stroke has to take a horizontal direction; to draw an expanse of grass—the line must be vertical; to draw an arm, the line must be cylindrical, and so on. There may be exceptions to this rule, but generally speaking the line should explain the form (fig. 189).

And one last piece of advice:

The parts are subordinate to the whole. Concentrating solely on the grapes in my subject, forgetting about the rest of the picture would be a mistake. No, you have to see the whole picture and do it *all at the same time*, ALL AT THE SAME TIME. Treat the subject as if it were an image that, little by little, appears all at one time until it is complete.

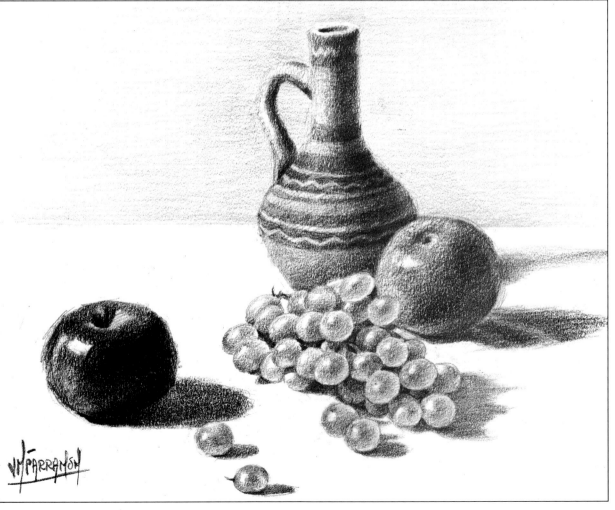

Drawing more difficult subjects

Now you have finished your drawing, and I have finished mine. Mine was a relatively easy subject, with just the one difficulty, that of the grapes. But, even so...

Say I had changed something in my drawing. If, for instance, I had put an extra grape, or one grape fewer, nobody would notice the mistake; no one would say that there was a grape missing. Or say you drew a landscape, eliminating a telegraph pole or putting a tree in a different place. Nobody would know. But some subjects do not allow you to change anything or make mistakes. Look at the drawings of Marilyn Monroe on this page. In one of them, I have deliberately changed my calculations of the distances between some forms. In the lower drawing, fig. 193, the left cheek is slightly thinner, altering the shape of the left eye. There is too great a distance between the nose, which is more upturned in this picture, and the mouth, which is itself smaller, the right eyebrow is higher up, and so on.

In the upper drawing, the same head is perfectly adjusted, as you can see. This picture really "is" her; you do not say, "Yes, it looks like her, but, I don't know, it just isn't her." In his *Treatise on Painting* Leonardo makes a study of this problem and speaks of educating the sight, of learning to measure and judge proportion. Here is what he says:

Practice with your first glance and learn the true length and width of objects. And, to accustom your spirit, have one of your number draw a straight line on a wall with chalk while the rest of you, standing some 60 feet away from the wall, try to calculate its length. Then measure the line. The one whose guess comes closest to the true length shall be declared the winner. All these games help to form judgment of sight, which is the main factor in drawing and painting."

192

193

Figs. 192 and 193. There are some drawings or subjects that do not allow mistakes in calculation of dimensions and proportions. A little differences in Marilyn Monroe's figure misform the similitude as we can see comparing figures 192 and 193.

Well then, to follow Leonardo's teachings, let me propose that you complete the following exercises, which you can add to and repeat. Calculate and draw on fairly large sheets of paper, as the longer the line, the more difficult it is to calculate its length and the better practice it will be for you.

First do all the exercises, then see how good your mental calculation is. Draw and calculate other lines or similar forms, repeating the exercise time and again.

194

1

Fig. 194. 1. Draw a horizontal line as long as you can make it, then, divide it roughly in two with a stroke where you feel the center should be.

2

Fig. 194. 2. Draw a horizontal line then another half its length.

3

Fig. 194. 3. Draw the lines of a square in the order shown in this diagram.

4

A　　**B**

Fig. 194. 4. First, draw a vertical line, then a Saint Andrew's cross (or X), calculating the distance from A to B so that it will later form the sides of a square. Then close the sides so that you have a square with a Saint Andrew's cross in the middle.

The right perspective

Parallel perspective and oblique perspective

Perspective is a wide-ranging, complex, mathematical subject, one that could on its own fill the pages of a book of this type. But we are not mathematicians or architects. We simply have to keep things in perspective, so as not to make beginner's errors and to be able to draw freehand, or from memory.

Below are basic facts that you need to bear in mind about this subject.

The elements of perspective are:

The horizon line (HL)
The point of view (PV)
The vanishing point or points (VP)

The *horizon line* (HL) is a horizontal line, level with the observer's eyes. You can see a classic example of this element in figs. 195, 196, and 197 on this page, in which the horizon is represented by the line dividing the sea and the sky. Notice that when the observer is seated the horizon is lower, and when she stands the horizon is correspondingly higher. As its name indicates, the *point of view* (PV) is determined by the direction in which the observer directs her gaze.

The Vanishing point or points are also located on the line of the horizon, performing the same function of joining apparently parallel or oblique lines. There are three types of perspective:

Parallel perspective (one PV)
Oblique perspective (two PVs)
Aerial perspective (three PVs)

In fig. 198 on the next page, you can see an example of parallel perspective with one vanishing point. Note that the nearest sides (A, B, and C) of the blue cubes are parallel to the plane of the image and that all the lines which vanish to one point on the horizon appear to be parallel to each other.

195

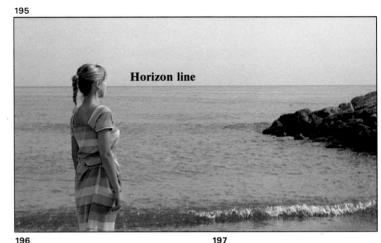

Horizon line

196 **197**

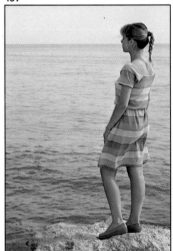

In the photograph at the bottom of the page (fig. 201), there is a classic example of parallel perspective with two vanishing points. In this case, the horizontal "parallel" lines recede towards the horizon, forming two converging series of lines, which meet at their respective vanishing points.

In figs. 199 and 200 we can see a typical mistake in perspective, commonly occurring with cubes, buildings and similarly shaped objects. This mistake can be clarified by pointing out that the angle formed by the base of the cube must always be greater than 90 degrees (fig. 199). When this angle is less than 90 degrees the cube is deformed (fig. 200).

Figs. 195 to 197. A classic example in which the line of the horizon is the point dividing the sea from the sky. You have to imagine this line, remembering that it lies in front of us, level with the eyes as we look straight ahead. This line becomes lower or higher with us if we bend down or move to a higher vantage point.

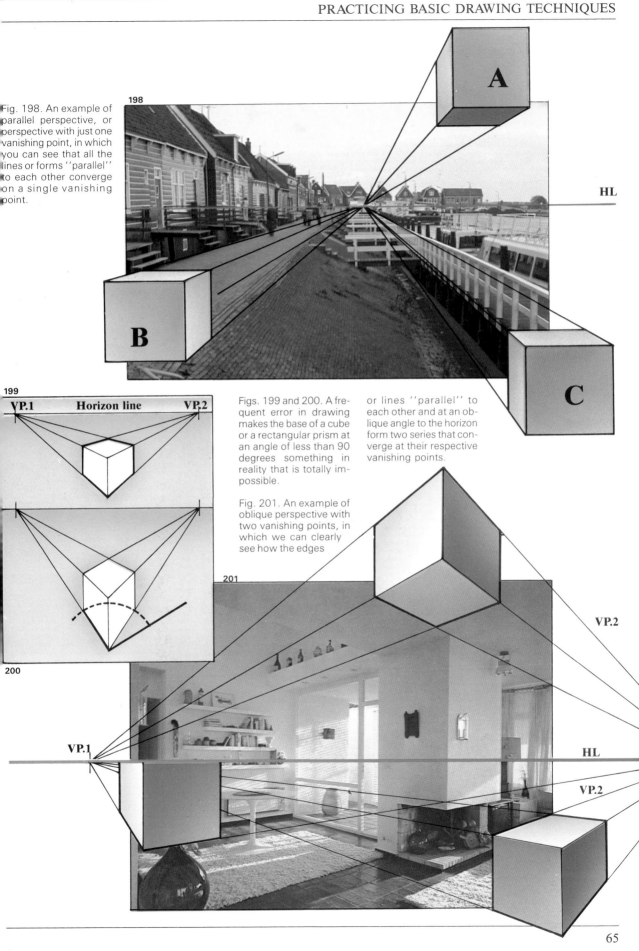

Fig. 198. An example of parallel perspective, or perspective with just one vanishing point, in which you can see that all the lines or forms "parallel" to each other converge on a single vanishing point.

Figs. 199 and 200. A frequent error in drawing makes the base of a cube or a rectangular prism at an angle of less than 90 degrees something in reality that is totally impossible.

Fig. 201. An example of oblique perspective with two vanishing points, in which we can clearly see how the edges or lines "parallel" to each other and at an oblique angle to the horizon form two series that converge at their respective vanishing points.

Aerial perspective

Aerial perspective is used to portray a subject from far above or below the line of the horizon. It differs from parallel and oblique perspective in that vanishing points are above or below that same line. In fig. 202, you can see a cube seen from above from an aerial perspective of three points, and in fig. 203, a New York skyscraper photographed from a low point of view, also in aerial perspective with three vanishing points. Note that the lower sides of the blue cubes correspond completely to an oblique perspective, with two vanishing points. The lateral sides, however, vanish or recede to a third vanishing point located above the line of the horizon.

Figs. 202 and 203. Diagrammatic drawing of a cube in aerial perspective with three vanishing points, together with a practical example of this type of perspective applied to a New York skyscraper in which the line of the horizon is below the picture, as you can see from the edges or lines that vanish at the two points situated at the bottom, at the two sides of the building. Note in the drawing of the cubes that this type of perspective is the same as oblique perspective with a third vanishing point going off above or below, according to the position of the viewer.

Figs. 204 to 207. Here we can see the construction of a circle and how this and a cylinder are placed in perspective, with examples of some typical errors in the drawing of the latter.

Perspective of a circle and a cylinder

Let us now see how to draw a circle and a cylinder in perspective, beginning with a circle drawn freehand. We start by drawing a square around the circumference of the circle we want to draw. Then we draw the diagonals (fig. 204A) and the median lines (fig. 204B), marking three equal portions on one of the median lines (fig. 204C). Starting from the furthest of these points from the center, we draw another square within the first, its sides parallel to the outer square (fig. 204D). In this way, we find points a, b, c, d, e, f, g, and h; these are points on the circumference of our circle (fig. 204E).

Now look at the steps you have to follow when you take a square in oblique perspective as your basis (fig. 204F), bearing in mind that there is in fact no difference between a circle in parallel and oblique perspective; the result is always an oval (figs. 205A and 205B).

To draw a cylinder, you start with a rectangular prism, as you can see in figs. 206A and 206B. Now take a look at some typical mistakes in the construction of a cylinder: The first (and most common) is the error of drawing points or angular shapes at the sides of the circles (fig. 207A). Another frequent mistake is that of drawing the circle corresponding to the base with a false perspective (fig. 207C), and another is that of drawing the body of a cylinder without bearing in mind the effects of its foreshortening or perspective (figs. 207E and 207F).

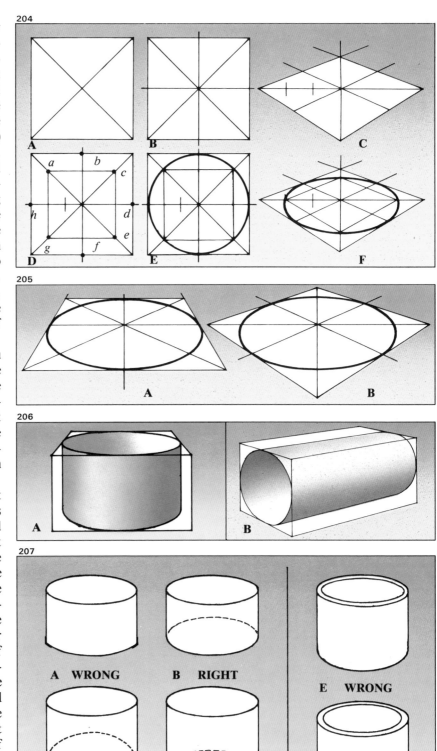

Dividing space in depth with parallel perspective

To determine the perspective of a depth with regular, visible, equal divisions like a tiled floor, we first draw the shape of the floor (fig. 208A), a receding "rectangle" with one vanishing point, and we divide the nearest side up into as many spaces as we want tiles in each row. From these points we draw lines receding to the vanishing point. Then, roughly calculating, we mark off the depth of, say, three tiles by three—the area marked *a* in fig. 208B. Now we draw a diagonal line through points *b* and *c* (fig. 208C). The intersections of this diagonal line

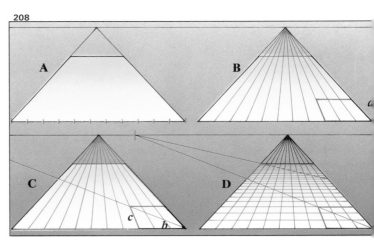

208

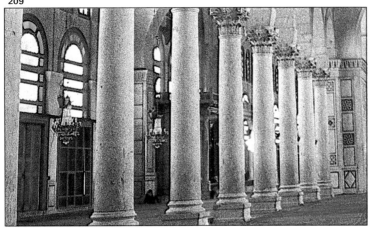

209

Figs. 208 to 210. Series of columns, openings, doors or windows with spaces between going off into the background is a frequent theme in drawing or painting, particularly in buildings and urban landscapes. The same is true of mosaics depicting interiors. The professional usually solves these problems at a glance, but I feel it is a good idea for the reader to study the examples provided here, concentrating especially on drawing mosaics.

with the receding lines of the rows of tiles give us reference points to mark in the horizontal lines which complete the mosaic (fig. 208D).

Another way of placing depth in perspective is illustrated in fig. 210, which shows you how to draw the columns in fig. 209 in perspective. First, you draw a *measuring line*. As you can see in fig. 210, this line runs from point *c* to point *e*. Another special device, the *measuring point* (MP), is placed on the horizon of the vertical line *ac*. From the measuring point, you draw a diagonal line to point *e*, passing through point *d*. Then you divide the distance from *c* to *e* into nine equal parts (fig. 210A) and draw a series of diagonal lines from these marks to the measuring point (fig. 210B) and, that is all there is to it!

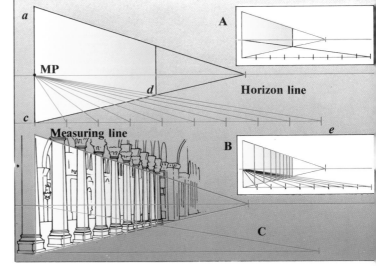

210

Dividing space in depth with oblique perspective

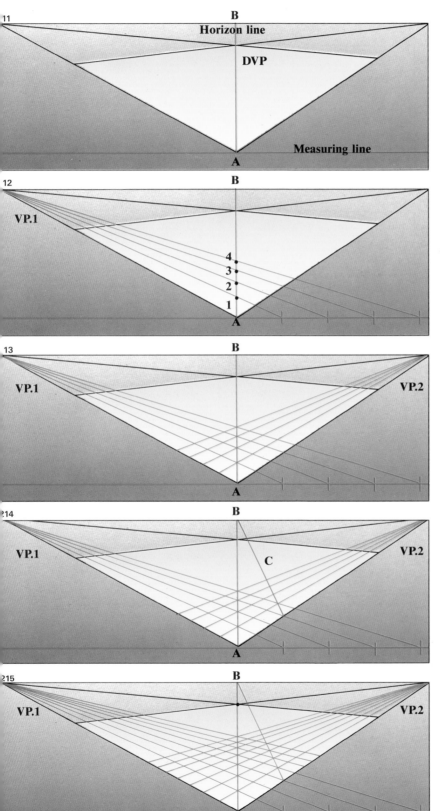

To draw a tiled floor in oblique perspective, first we have to establish the horizon. Then we draw the oblique perspective of the shape of the floor. Next we draw a line parallel to the horizon which will be the *measuring line*, starting out at the point nearest the viewer. Now draw the vertical line AB from the measuring line to the horizon to find point DVP, which will be the *diagonal vanishing point* (fig. 211).

We then divide one half of the measuring line in, say, four equal parts. From these divisions, we draw receding lines to point VP.1, getting points 1, 2, 3, and 4 on the diagonal line AB (fig. 212). If we draw receding lines from these points to point VP.2, we will obtain a series of 4 × 4 tiles (fig. 213). Watch carefully now. By drawing a diagonal line from the last tile on the right, we get new reference points (fig. 214) which mean we can draw more lines receding towards point VP.1. And we can complete the floor.

Figs. 211 to 215. The masters of the Renaissance invented perspective, basing their principles on the drawing of mosaics such as those you can see on this page. And it was on the basis of these squares in perspective that they drew bodies and buildings in perspective. Bearing this in mind, I can only repeat my advice: study and practice drawing mosaics in perspective.

The perspective of shadows

Imagine a room with a light bulb hanging from the ceiling, shining onto a square surface standing on the floor. Bearing in mind that *artificial light radiates in straight lines*, if we could separate the beams of light shining on the square surface from the rest, we would see an angle formed by the sides of the beams (A and B), leading to a point at the source of light and casting a shadow of the figure (fig. 216). The conclusion we draw from this is that:

In shadow perspective, the point of light becomes the *light vanishing point* (LVP), the place where the rays defining the shape of the shadow converge. To complete the system, we need another point to fix the position and direction of the shadow on the floor with respect to the position of the light.

You can see this second point in fig. 217. It is the *shadow vanishing point* (SVP), which you can place by following the line of the light to the floor.

In this same figure, you can also appreciate the overall effect of all the vanishing points. Here we can see VP.1 and VP.2. Now we only have to decide at what level the SVP has to be placed, by "transferring" the LVP to the floor— *projecting*, to give it its technical name—the position of the light hanging from the ceiling. In fig. 217 we can see an example of this simple projection, operating with oblique perspective.

This operation gives us VP.2, a normal vanishing point where the horizontal lines B and C intersect with the wall. To help you to assimilate all this, study in the following illustration a complete, overall demonstration of shadow perspective when working with artificial light.

216

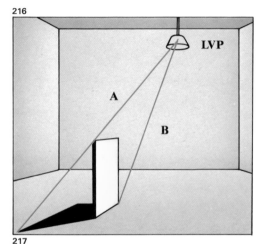

217

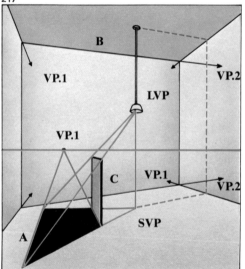

218

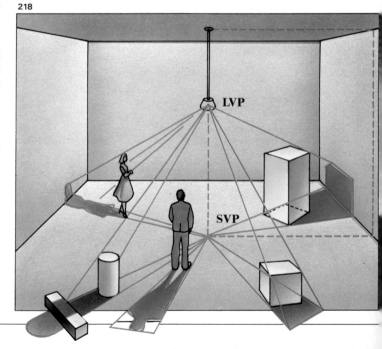

Figs. 216 to 218. When drawing or painting the perspective of shadows with artificial light, the following norms apply. artificial light emanates in straight lines radiating from its source. The light vanishing point (LVP) in the source of light determines the shape of the shadows. This point, however, has to be combined with the shadow vanishing point (SVP), which is found by drawing a vertical line to the floor starting out from the light vanishing point. To place this last vanishing point, make a small projection in perspective like the one in fig. 217. The rest you can deduce for yourself from the accompanying illustrations.

The perspective of shadows cast by natural light

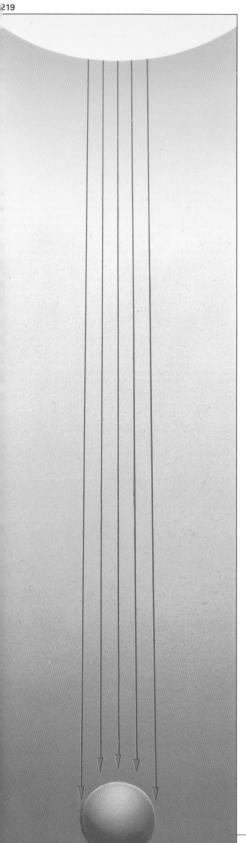

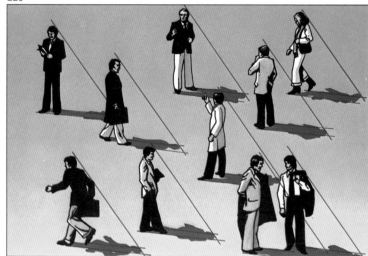

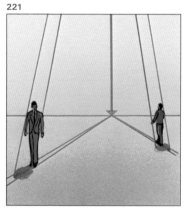

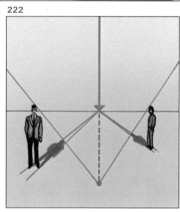

The enormous size of the sun and the incredible distance between it and the Earth mean that there is practically no radial effect in the light which it emits. Therefore, we can say that *natural light shines in a parallel direction* (figs. 219 and 220). (That is how we see in aerial perspective when we are looking out from a high position). If we look from a position of normal height, there will always be a *shadow vanishing point* on the horizon, as well as a *light vanishing point*. When the sun is in front of the observer, the LVP will be the sun itself and objects will be seen in backlighting, as is the case in fig. 221.

When the sun is behind the viewer, the *light vanishing point* will be on the level of the earth, below the horizon (fig. 222).

Figs. 219 and 220. Natural light emanates in a parallel direction, so that, when we look at an object from a higher point, we see shadows falling all in the same direction.

Figs. 221 and 222. Drawing from a normal plane with natural lighting, when objects are in backlighting and the sun is in front of our eyes, the light vanishing point (LVP) is the sun itself. When the sun is behind us and the shadows therefore fall behind the bodies, the light vanishing point is found at ground level, below the line of the horizon.

Value: how to compare and classify tones

When we observe and paint the effects of light and shade, we are valuing the tones of the subject. This is an important aspect of the art of drawing, since the volume of the bodies and the artistic quality of our work depend on this.

Values are tones
Valuing is comparing

Valuing consists of mentally classifying tones and shades of color, comparing each with all the others to find which are darker, which are lighter, which are intermediary tones.

This concept is easy enough to understand. But it is when we come to the actual practice of valuing that difficulties arise.

The first and most common mistake occurs when the artist *overly darkens the tones*, giving his picture an intense, false scale of values. An example of this error is shown in fig. 223A, where, analyzing the scale of values, we see that there are not enough whites and light grays. Another common mistake, illustrated in fig. 224 and its corresponding scale of values in fig. 224A, is to value *using too few intermediary grays*.

The basic formula to follow so as not to make mistakes like these is to

Compare and value progressively.

Look, compare, then look again, using fixed tones like black and white as your basis of comparison—there are white and black areas in any subject. Compare the intensity of a dark gray with the black and a light gray, with white and a dark gray, adjusting and differentiating between them. Bear in mind that colors closer to the foreground are darker than those further away.

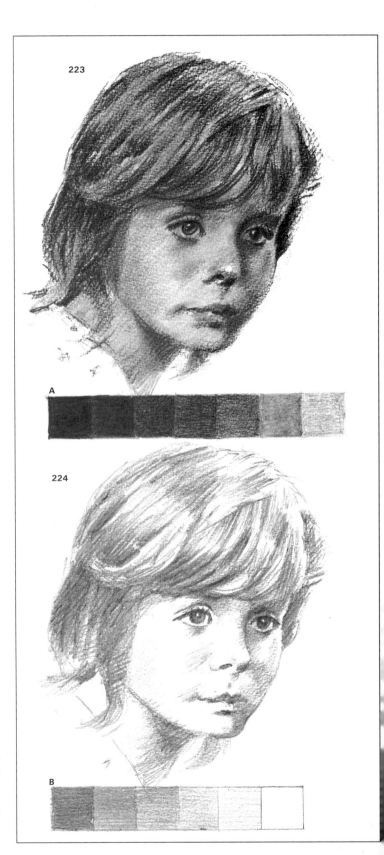

Figs. 223 and 224. Two examples of mistakes in valuing tones. In the first, in fig. 223, there is an excessive overall darkening, even in the features of the face with the most light on them. In fig. 224, the mistake is the opposite one. The artist has not gone far enough, and the result is timid and indecisive. Fig. 223A and 224A show the scales of grays for both.

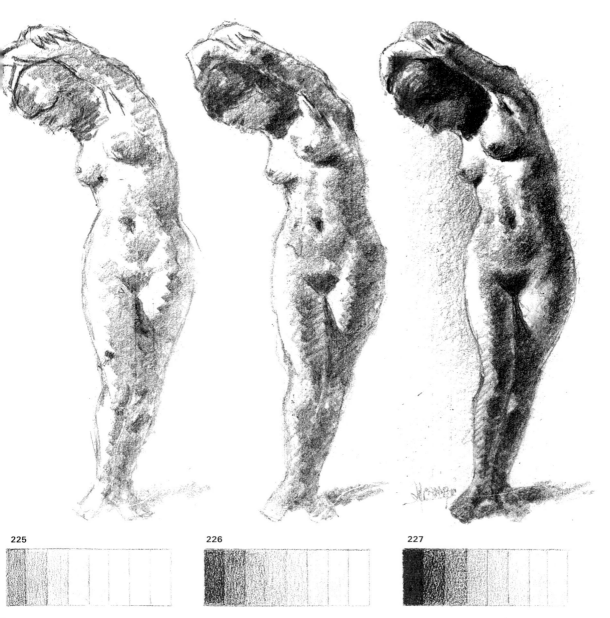

225

226

227

Figs. 225 and 226. In this study we can see the step by step process of gradually valuing a drawing in lead pencil.

Fig. 227. A wide range, from a deep black to light grey or dirty white, allowing the artist to portray the volume of the bodies.

Always value progressively, getting the middle tones first. Use a "weak" scale of values, composed of different shades to express volume (fig. 225), then go on, heightening the tones gradually, step by step, *at the same time as you draw*, until your picture is finished (fig. 226).

Don't forget to draw LIGHT.
Remember what we said on page 60, that bodies are not given form by lines; bodies are not constructed of wires. Draw with lights and shadows. Take a look at the nude in fig. 226. Note that the profile is expressed, not by lines or pencil strokes, but by the light of the body, strengthened by the soft shadow of the background.

As a complementary technique, use an old formula known to all artists,
Half-close your eyes
To do this, squint a bit. Why? Well, first, *you eliminate small details from your sight*. Second, *you accentuate contrasts*. The former means that you see the subject in synthesis, that is, *you see only tones, colors*. For when you half-close your eyes, you blur images. As a result contrasts between objects are intensified.

Light and shade

Light is an essential factor in the conception and execution of a picture. It has even been the basis of such painting styles as *tenebrism*, influenced by the work of Caravaggio, which characteristically used violent contrasts; and *impressionism*, in which light was the main actor; and *fauvism*, because its adherents painted in "pure" colors.

In practical terms, light allows the artist to express or suggest moods or feelings. Bear in mind the following factors:

The quality of the light
The direction of the light
The quantity of light

The quality of the light

Before the invention of the eletric light, the grand masters of painting worked in the studio under *natural light* shining into the room from above, through a skylight or a high window. This quality of light is evident in the painting *The Spinners*, reproduced in figure 227, which Velázquez painted in his studio, lighting the figures in the background with the beam of light you can see. In the following figure, number 228, we can see how a studio looks nowadays. This is my studio in fact, illuminated from above with natural light.

This lighting, the classical form of illumination, gives soft transitions, conveying volume without contrasts, as we can see in fig. 229. Compare artificial light or direct sunlight. This light is hard and dramatic, creating strong outlines (fig. 230).

The direction of the light

There are five possible directions in which light can shine:

1. Frontal lighting (fig. 231). Not recommended for drawing, this lighting is ideal for painting in a "colorist" style, disregarding value and expressing forms with flat colors lacking in shadows.

2. Lateral front lighting (fig. 232). This type of lighting best expresses form and volume. It can be used when painting or drawing any subject.

3. Side lighting (fig. 233). This type of lighting adds drama to the subject and is recommended for drawing and painting still lifes and figures. It is often used for self-portraits.

4. Backlighting (fig. 234). This lighting is full of special effects, especially when it is possible to soften contrasts by reflected light in the area in shadow.

5. Light shining from below. It is unusual to make use of this type of illumination nowadays, but it is a fine medium for expressing fear, panic, terror, etc. Goya used this type of lighting in his painting *The Executions of 3 May 1808.*

Fig. 228 and 229. Velázquez. *The Spinners*. Prado Museum, Madrid. Like all the grand masters, Velázquez painted in his studio with indirect natural light shining in through a skylight or a window placed higher than 1.5 meters (5 feet) from the ground. In fig 229, there is a modern artists's studio—mine—illuminated with this type of lighting.

228

229

230A

230B

The quantity of light

Obviously, quantity of light plays a decisive role in the final effect of a picture: a powerful light, especially if diffused, minimizes and can even eliminate the contrasts of light and shade. A weak light, on the other hand, makes contrasts stronger, to the point of making the parts in shadow completely black in some cases.

When you are choosing a subject, consider the type of lighting. As Georg Hegel, the German philosopher, wrote in his work *System of the Arts*, "*The theme of a picture is intimately related to the form of lighting.*"

231

232

233

234

Figs. 230A and 230B. The subject is lighted softly and indirectly. This light does not accentuate tone contrast (fig. 230 A). Compare the same subject illuminated by an artificial light that allows us to appreciate the hardness and contrast of tonal values (fig. 230 B).

Figs. 231 to 234. Four classic examples of different directions of lighting on the same bust of Socrates. Fig. 231, frontal lighting; fig. 232, lateral frontal lighting; fig. 233, side lighting; and fig. 234, backlighting.

Contrast

Resolving the problem of contrast is closely linked to resolving that of value. For, as Leonardo da Vinci said in his *Treatise on Painting*, "The artist has to identify the lights that form the areas of greatest clarity and the shadows that are the darkest, how they are mixed and how much." He adds, "he has to compare one with another." That is to say, the basis of value is to be found in *comparing tones*. To heighten contrast, there are other factors which should be born in mind:

1. Contrast can be of tone or of color.
2. Contrast can be false, created by the artist.
3. Contrast can be simultaneous.

1. Contrast of tone; contrast of color. Tone contrast is the comparison of a dark tone with a light tone.

Color contrast is brought about by *two different colors*: blue and red, blue and light green are examples. Maximum color contrast is produced between complementary colors.

2. Creating contrasts. M. Boussett, the painter and teacher, explains in one of his books, "Titian deliberately darkened the background of his landscapes to make the figures in the foreground lighter, to make them stand out more." Cézanne uses the same trick in his still life paintings, heightening the forms and outlines of pieces of fruit, jugs, baskets and tablecloths with intense shades to delimit, outline and reinforce forms and colors.

3. The law of simultaneous contrasts. This law explains what Titian, El Greco and Cézanne did.

The darker the surrounding tone, the whiter a white will be, and the lighter the surrounding tone, the darker a gray will be.

Of course, the artists mentioned knew this law and applied it to create contrasts. You will remember it better if you note that gray boxes in figs. 235 and 236 are of an identical tone, though, to the eye, the gray surrounded by black seems lighter and the gray seen against a white background seems darker.

There is just one more question to mention on contrast: "When do you think that the color of an object is lighter, when it is nearer to you or further away?" The answer lies on the next page, for this is a problem of contrast and of atmosphere.

235

236

237
238
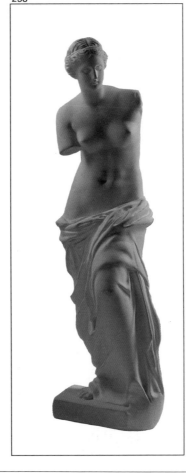

The atmosphere

Figs. 235 to 238. According to the law of simultaneous contrasts the darker the surrounding tone, the lighter a gray will appear, and vice versa. You can see this for yourself in the two gray boxes and the pictures of the *Venus de Milo*, noticing that the gray seems lighter when it is on a black background and darker when seen against a white background.

Figs. 239 and 240. The plan and drawing in lead pencil of these figures demonstrate Hegel's idea that the foreground contains the greatest contrasts—that contrast decreases with distance.

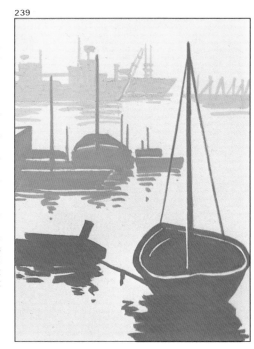

239

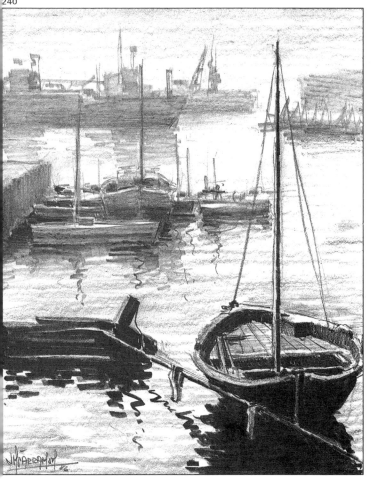

240

The direct relationship between value and contrast lies in the atmosphere, the air. The problem is, to represent this atmosphere in your drawings or paintings or to imply it, since it is often hard to perceive. We will now answer the question posed on the preceding page. But first, allow me to detail the factors that determine the feeling of atmosphere:

In drawing or painting, atmosphere is portrayed by:

1. *A strong contrast between the foreground and the middle and background.*
2. *Discoloration and a tendency towards gray as the eye moves further into the background.*
3. *Greater clarity of the foreground in relation to the middle and background.*

Hegel states rightly that

"The foreground is darker and is at the same time lighter."

This really means that in the foreground, colors are not lighter or darker, but there is a *greater contrast of tones*. In other words, what we have is a basic rule which we should remember:

Contrast decreases with atmosphere.

Observe the illustration fig. 240: the foreground has been completed almost entirely in black and white, with total contrast, using the most intense black that can be achieved with a 9B pencil. The boats of the middle ground, because of the atmosphere between, are of a medium gray, more gently contrasted. The gray background is blurred, diluted, without contrast. The forms are intuited rather than clearly delineated.

A good drawing, and a good painting, is always somewhat ethereal. The representation of atmosphere and of the third dimension comes from drawing and painting air, from stumping outlines. In the portrait, the outlines of the figure, in the still life, the elements of which it is composed, and in a landscape, the outlines of the mountains.

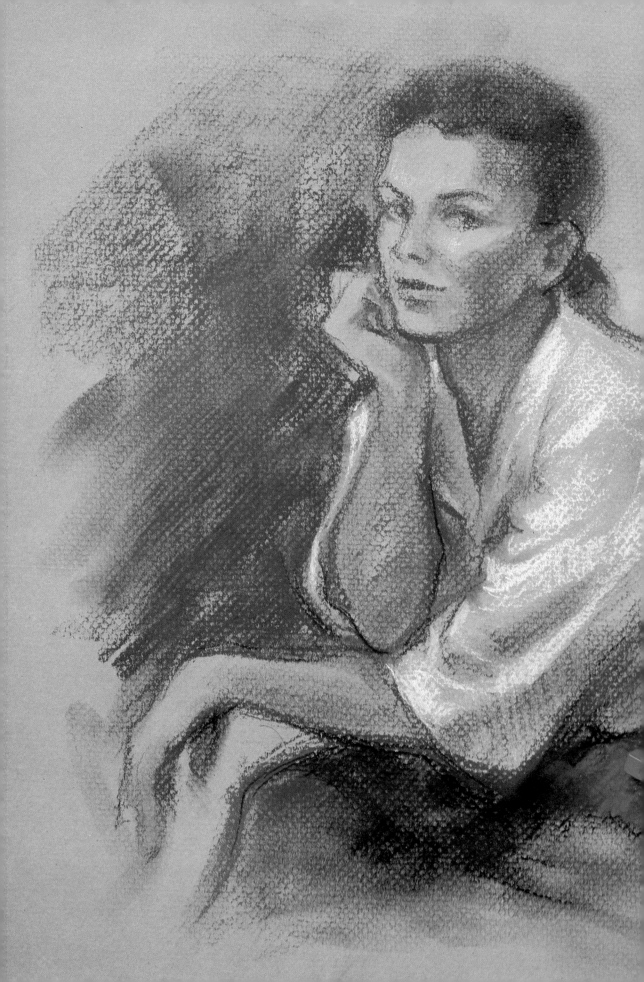

To sum up all we have said until now, we will demonstrate a number of practical exercises using different media, beginning with a series of sketches. Next we will draw a figure in charcoal pencil, a hen in wax crayons, a *storyboard* (you will soon find out just what that is) in marker. We will paint a watercolor landscape using just two colors, a bunch of flowers in pastels. We will draw a nude in chalk on gray paper. I will explain how these drawings are done step by step, but you must do more than just read and look. You must put at least two of these exercises into practice, so that all you have read and seen up to now can start to bear fruit in your work.

Drawing in practice

Make sketches

Make sketches—quick sketches, slower sketches. Give yourself a time limit for practicing your strokes with a spontaneous free hand. Time yourself, first allowing yourself ten minutes, then five, then three...

You just need a block of paper the same size or a little smaller than the pages of this book and a fairly soft pencil, such as a 4B, or, better still, a 4B or 6B all-lead stick. You can also draw with chalks or markers (using just three or four—black, sienna, ochre and gray, for instance), even with India ink and nib. Look at the sketch reproduced in fig. 245 on the following page. I drew fig. 246 on the terrace at a bar while this young person read a book. The drawing at the top of the page (fig. 244) is of my son watching television. Next to that (fig. 243) is of myself looking into a mirror. There are themes everywhere—at home in front of the TV, when the baby of the family, or the eldest member, is having a nap, yourself in front of the mirror, in the street, in a bar, on the train, in the park, at the zoo. Have you ever sketched at the zoo, or on a farm with hens, ducks, rabbits, pigs, cows, horses and so on? If not, you do not know what you are missing. It is wonderful and different—a splendid adventure which only people like you, who know how to draw, can take part in.

Sketching is the same as painting practice pictures to learn to paint more freely, with greater skill, with more art. For when you sketch, you do so without worries or conditions, with no obstacles, trying things out and experimenting with absolute freedom. When this way of drawing becomes part of the artist, that is when the mark of genius appears on the paper.

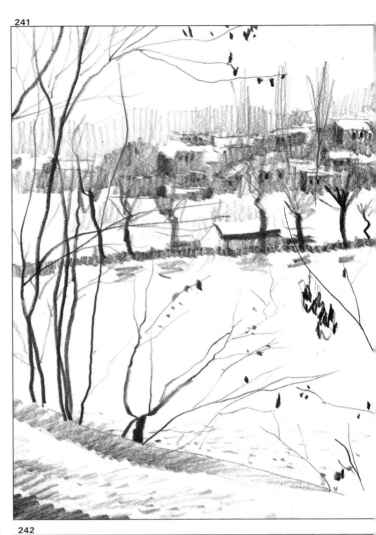

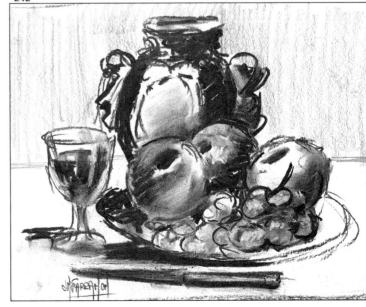

Figs. 241 to 246. Sketching has to be a constant occupation, an exercise that maintains and perfects technique and skill, increases creative capacity and the ability to draw freely. As Van Gogh said, "Sketching is like sowing seeds from which you will later harvest pictures." On these pages, you can see various sketches of different themes, in a variety of media.

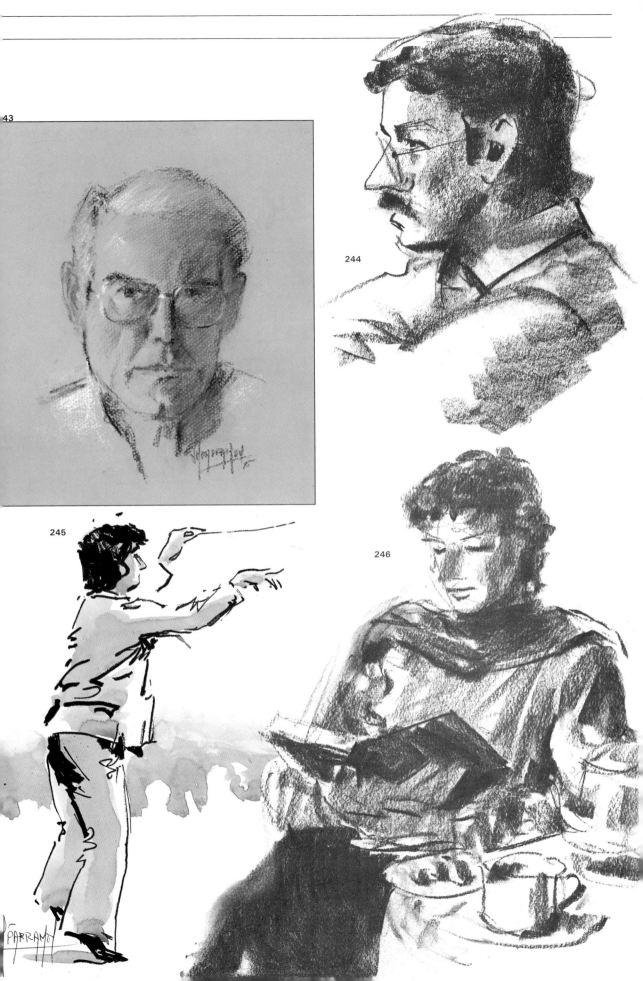

43

244

245

246

Miquel Ferrón draws a sketch for a portrait in charcoal penci highlighting with white chalk

247

248

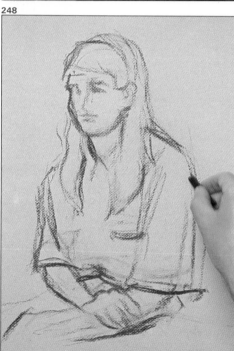

249

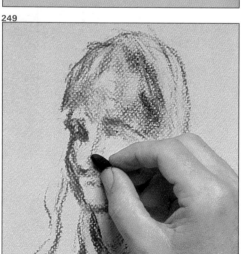

Ferrón is the artist, and Esther, a graphic designer, is today posing as a model. The materials are mi-Teintes gray paper, charcoal pencil, and white chalk.

Ferrón spends a good time studying the model. He looks at the paper, then at the model. Now, he is trying out his stroke, calculating, comparing.

With surprising sureness of hand, he suddenly starts to draw, outlining the form with broad strokes (figs. 248 and 249), without a pause, his hand moving with almost feverish impatience. The likeness begins to take shape on the paper (figs. 250 and 251).

Abruptly, he stops and says he has not given the body enough height. "I'll erase with my hand and make the body longer to give it more height." You can see this mistake and how it was corrected by comparing fig. 251 with the finished drawing in fig. 254.

Then he continues reinforcing lights with the white chalk, illuminating the face and the blouse of his model (figs. 252 and 253).

He finishes by outlining and strengthening energetically, completing his work without forgetting the idea of synthesis behind this sketch expressed in the form and interpretation of lights and shades.

250

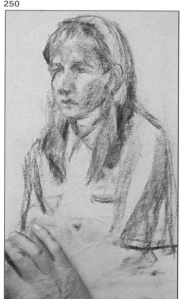

251

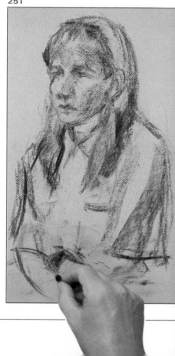

Fig. 247. The artist M quel Ferrón and th graphic designer Esthe who is posing for a po trait in charcoal penci

Fig. 248. Ferrón's initi framing goes quickly.

Figs. 249 to 251. Ferró draws the face, fig. 249 correcting his first lines fig. 250, and structurin the body, fig. 251. Then noticing immediately tha the proportions of th head in relation to th body are wrong, he co rects his mistake, as yo can see by comparin this figure with fig. 25 on the next page.

gs. 252 and 253. The
rtist begins to draw
ghlights in white chalk,
arting with the face and
arrying on down to the
olds of his model's
ouse, the proportions
f which he has already
orrected.

g. 254. The completed
ortrait with the fluency
f the quick sketch and
e finished drawing
uality.

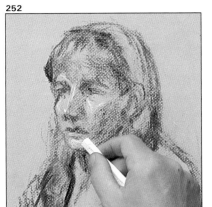

252

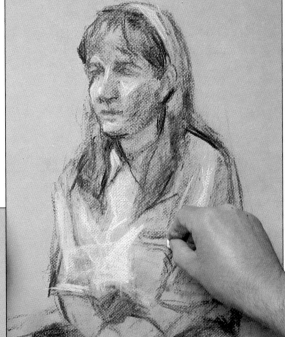

253

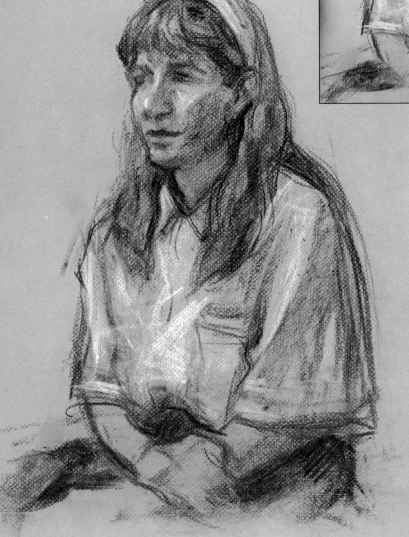

54

255

Drawing a hen in wax crayons

Vicenç Ballestar is a professional artist with an extraordinary knowledge of the drawing and painting of animals. Most often he paints in watercolor, but he is a master of all media. Here, he will use wax crayons to draw a hen.

I went with Ballestar to a poultry farm in the country. Ballestar, the photographer, and I went in and made ourselves comfortable in the henhouse to work better.

Well, to be honest, we were not at all comfortable.

Ballestar chose a hen with peculiar markings on its feathers (fig. 257) and, without further ado, sat on his folding chair with a block of drawing paper in his lap and his wax crayons in a box on the floor. He started to draw. Let us see what he does and how he does it.

With a sepia crayon, so dark as to be almost black, he draws the outline of the hen. Then, using the same color he draws a series of curved, parallel strokes which, together with other patches in the tail of the hen, below the wings and at the top of the neck, give a general form to the drawing. He adds a few touches of ochre (fig. 261) setting this off by scratching with a razor blade, "drawing" lines and patches. He finishes the drawing and scratching of the tail and paints the crest red. Finally he draws the eye, the details of the head and the feet. Naturally, the hen has been moving around all the while, but, as we can see in fig. 258, Ballestar has captured its structure in the first stage of line drawing, and from now on...

"From now on," Ballestar breaks in, "It's just a question of synthesis and graphic work, which you learn, you can learn, by working hard, drawing a lot."

Fig. 256. Ballesta produces interestir drawings using his w crayons and razor.

Fig. 257. The "model, a nervous hen with blac feathering adorned wi symmetrically place white stains. A difficu subject to draw, becaus of the constant mov ment of the hen and th complexity of its pl mage.

Figs. 258 to 260. Vicenç Ballestar, an expert artist in drawing and painting animals, begins to draw the hen in dark sepia wax crayon, first getting the outline, then going on to paint the plumage with broad, curved parallel lines (Fig. 259), which he transforms into symmetrically-placed areas representing the body of the hen.

257

256

258 259

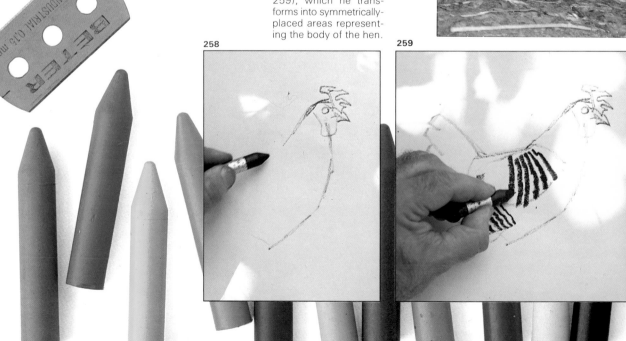

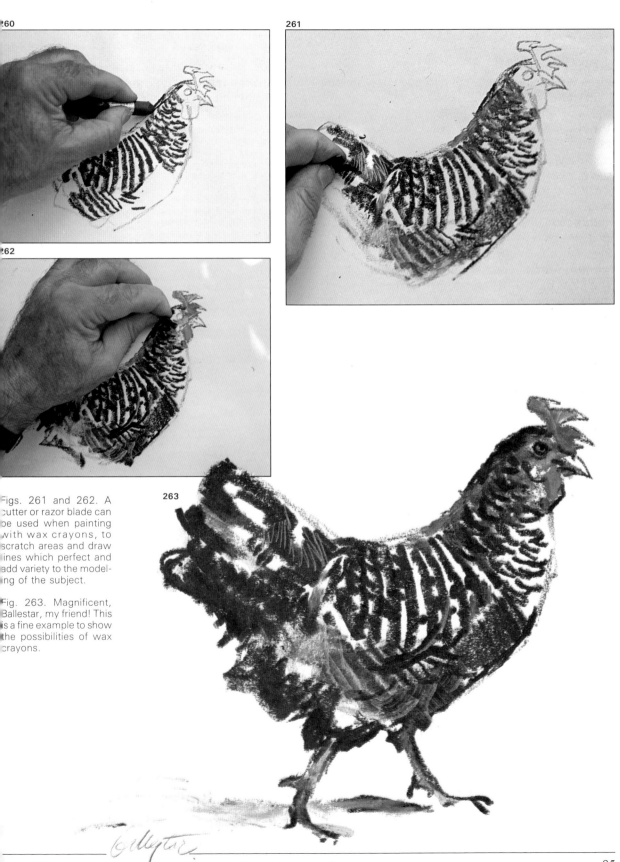

260

261

262

263

Figs. 261 and 262. A cutter or razor blade can be used when painting with wax crayons, to scratch areas and draw lines which perfect and add variety to the modeling of the subject.

Fig. 263. Magnificent, Ballestar, my friend! This is a fine example to show the possibilities of wax crayons.

Creating and drawing a storyboard

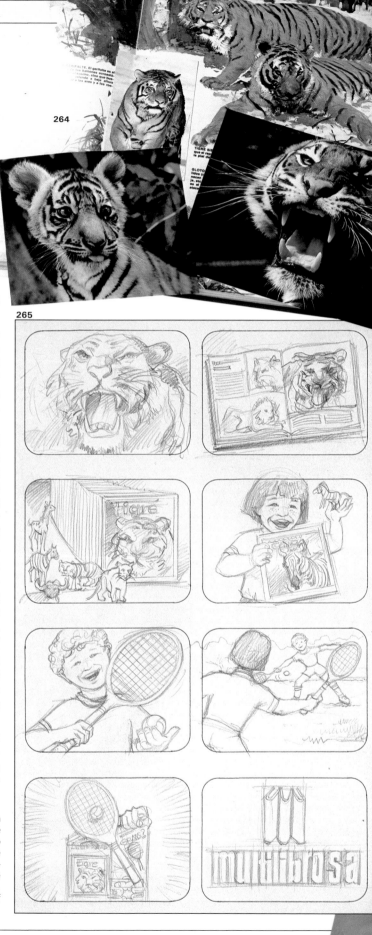

Fig. 264. To draw a storyboard or any other type of illustration, you must first get reference material, unusual subjects likea tiger are extremely difficult to draw from memory.

264

265

A commercial storyboard is basically the graphic outline for a television commercial.

Television commercials, known as spots, are dreamed up by advertising agencies. The first step in the creation of a spot consists of writing a very short text or script and then a graphic plan (the storyboard) to serve as the basis for filming the commercial.

Our guest artist, Miquel Ferrón, is well acquainted with this subject. He has drawn dozens of storyboards, and he is going to draw the one reproduced on this page, for a commercial recently shown on Spanish television. It was a spot for a collection of thirty volumes about *Wild Animals*, written and illustrated for children ages five to eight. The collection came out in thirty installments. To promote the series, the publishers were giving away free a collection of thirty plastic animals and a tennis game for children. Physically, the storyboard consists of one or two sheets of folio paper on which are printed various pictures of the shape of a television screen. Under each picture the script of the commercial is written.

Ferrón prepares to work by looking at some pictures of wild animals for reference. A tiger is what he most wants, as that animal appears in the first frame of the commercial (fig. 264).

Fig. 265. The storyboard is simply the original graphic idea behind a television commercial, used as a script to film and record a spot, as it is known in advertising jargon. The first step in creating a storyboard is to draw a sort of cartoon in which the plot of the commercial is put into images. Here we can see the drawings for a television commercial, the work of Miquel Ferrón, advertising a collection of children's books.

266

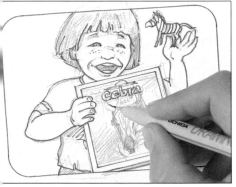

267

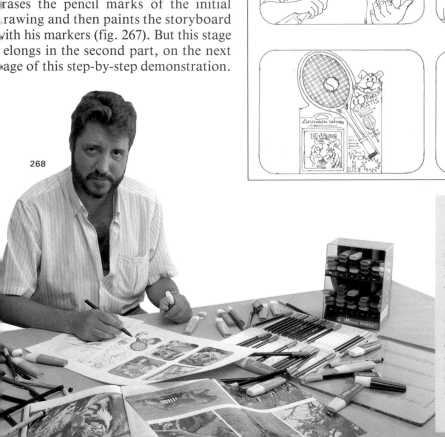

He draws a few preliminary studies to capture, adjust, and compose the images of each frame according to the written script. Next, he begins drawing the storyboard with a medium-grade lead pencil, an HB. He draws the tiger, and then, from memory, some children playing, some books and small animals, and so on. In the last frame, he draws the trademark of the publishing company (fig. 265). Now he goes over his work, adjusting his initial drawing with a fine-tipped number 05 marker (fig. 266). He erases the pencil marks of the initial drawing and then paints the storyboard with his markers (fig. 267). But this stage belongs in the second part, on the next page of this step-by-step demonstration.

268

Figs. 266 and 267. The initial drawing is made with a fine-tipped marker. It is then painted with markers, the medium typically used in this work.

Fig. 268. Miquel Ferrón at work on the storyboard that appears on these pages. He draws with a medium-grade HB pencil, going over it with a fine-tipped 05 marker, and painting with Edding 1300 markers, helped in the broad areas by Schwan Stabilayout markers.

Painting a storyboard with markers

Ferrón paints with a range of 89 alcohol-based markers produced by Edding 1,300 and a complementary range of 45 Schwan Stabilayout markers for broader lines (these are water-based markers available in 70 colors).

Ferrón paints frame by frame, using bright colors as is the norm for storyboards. A technical detail worth mentioning here is that he puts a scrap of drawing paper over the storyboard to protect his work, to try out colors, and to choose the best density, shade, tone, and so on. As you know, marker pens paint transparently in plain colors. These can be diluted with water, or, when you are using alcohol-based markers, with a *blending* marker. At first, it might seem that painting in transparency, as with watercolor, means that you have to superimpose layers of color to mix colors. Fortunately, however, the wide range of colors available allows you to choose exactly the color you desire without having to mix colors. As with watercolor, painting with markers requires the artist to go from less to more, first applying background and lighter colors, then painting the darker colors of the picture over these earlier layers. From this we can deduce that, as in the case of watercolor, painting with markers demands a high level of mastery of drawing. You must have an equally high-level mastery of color, since once you have painted something, you cannot erase or correct mistakes; there is no going back.

Look at the finished spot as filmed by the director of the television commercial which is reproduced on the next page (fig. 270). Notice that the shots are practically identical to the composition and framing of the storyboard.

269

Voice off: A collection of wild animals

Interesting texts to find out more

about your animal friends.

Voice of child: an animal with every book.

And with number one, these fantastic tennis raquets.

Begin your collection of wild animals today.

Fig. 269. The finished storyboard, rounded off by the trademark of the publishing company responsible for the advertisement. Notice the brilliance and contrast of the colors, normally a feature of this type of work.

Figs. 270 and 271. This is a graphic summary of the spot and a scene from it made by a film crew composed of director, producer, cameraman, directors of scenery and so on, with professional models working as the actors. Such a production is an expensive and laborious job that starts with the creation of the storyboard.

270

271

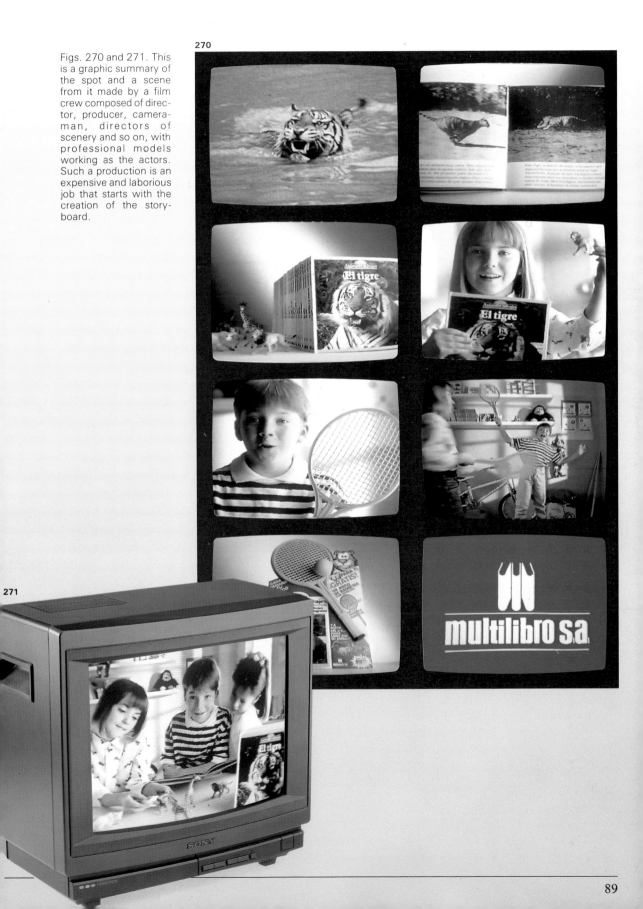

Painting a landscape in wash, using two colors

Fig. 272. First step: a well-constructed pencil drawing, including the play of lights and shades.

**Step one:
drawing the subject**

Painting is not easy. And painting in watercolor is especially difficult. To succeed, you have to master the art of drawing—framing, judging proportion, and valuing. In addition, you have to master working with color. You have to see it, and be able to paint with it. And to make things even more compli-

272

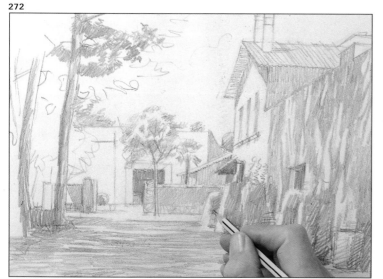

273

Fig. 273. I begin my wash with blue for the sky, which I gray slightly to paint the shadows of the clouds, then continue with a darker blue for the shadows of the large house and the wall on the right-hand side.

274

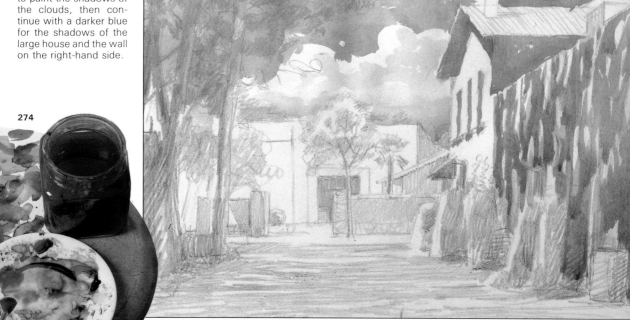

cated, in watercolor you have to master a number of special skills such as painting skies or uniform backgrounds, gradations, blending different colors, opening whites, absorbing paint onto your brush, painting wet on wet, and many more. "Divide and conquer," they say, so we will divide these three areas of difficulty by classifying them into two, drawing and other skills. I am going to paint a wash in two colors, employing drawing and watercolor painting techniques without entering into the problem of color.

Did I say two colors? Well, actually I will use four:

Prussian blue
Light English red
Black
White

My white is the color of the paper and my black is the result of mixing Prussian blue with light English red. If you have these two colors at hand, you can try this out for yourself. You will see that, depending on whether one or the other dominates in your mixture, you get a cold black of bluish tendency or a

warm, reddish black. You will also notice that with just these two colors it is possible to obtain a wide range of tones and shades of color comparable to a painting using all the colors.

This is what I do:

I begin my wash by drawing my subject with a 2B lead pencil. Notice, in fig. 272, how I have completed my drawing in medium gray tones. These grays will become an extra color in my picture, enrichening the combination of my Prussian blue and English red.

Step two:
First approach to color

I paint the sky with Prussian blue, painting the shadows of the clouds in a broken (grayish) blue, obtained by mixing in a little red. I put on a first layer of blue only for the shadows on the buildings, the windows, and the wall on the right-hand side (fig. 273).

Next, I paint in the pink of the houses opposite, using the red slightly grayed by a little blue for the roof (fig. 275). I finish this stage by painting the walls, which are in shade in the background, and the shadows on the ground with a layer of Prussian blue mixed with red (fig. 276).

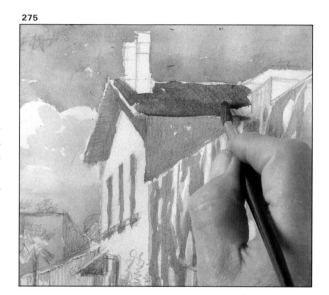
275

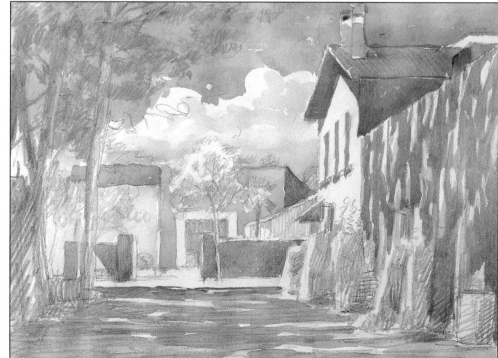
276

Fig. 274. I work with just two colors, Prussian blue and light English red, using a china plate as a palette.

Figs. 275 and 276. The color of the roof of the large house and the ground I paint with light English red mixed with a little blue, applying a little color in the background to begin to bring out the chromatic effects of this simple wash painting.

Step three: drawing and painting "at the same time"

I begin this stage by painting the trees on the left-hand side (fig. 277), drawing and painting the leaves and branches, giving volume to the trunks and so on—painting all these elements of my picture basically with Prussian blue mixed with English red for the darker parts. You can see this combination of colors in fig. 277 and 281 (the finished picture) on these pages.

At this point, I should warn you that you may miss green or yellow (which, mixed with Prussian blue, would give green), to paint the light, medium and dark greens of the leaves, branches, tree trunks and so on better. But we said at the outset that we were going to work on the skills of painting without worrying about the problem of color, and that is exactly what we are doing.

(I say "we" as if you were really painting along with me; I do think it would be a good idea for you to do exactly that using this or any other subject.)

As you can see in figs. 278 and 279, I go on to paint the chimney of the house on the right and the black of the door of the house in the background. I give the windows a touch of dark paint and spend most of my time working on the shrubbery, the door, and the bin that stands by the wall on the right. But I do not get stuck on these elements, for, as you can see in figs. 279 and 280, I have given a first layer of color to the tree and the angled wall in the background, and to the little roof over the door of the large house.

Basically, I have sought to work on my wash by seeing and painting everything, drawing and painting *all at the same time.*

Figs. 277 to 280. The first three illustrations show the painting of the trees on the left and the shrubbery on the right, as well as a few details in the background, but these are merely the prelude for the half-finished picture in fig. 280.

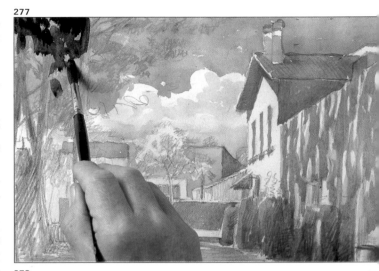

277

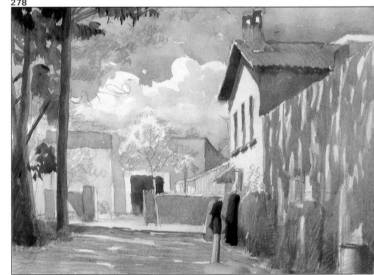

278

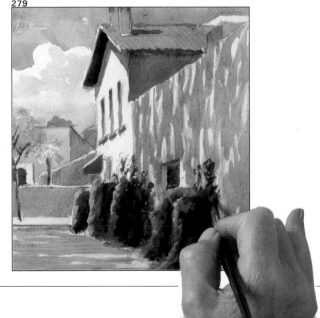

279

Step four, the last: the finish

There is little left to do now and less to say. Just finish the area of trees in the left-hand section, reinforce the contrast between the tree and the palm tree in the foreground, intensify the tones and colors of the door in the center, the threshold and the walls in the background, as well as that little roof, finish the windows and roof of the large house with a transparent coat of Prussian blue and a few strokes of a black ballpoint, finish the chimney, deepen the color of the shadow on the ground, finish the lower area, near the ground. Finally clean away the pencil marks left in the lights of the wall and the ground with my rubber eraser. Does this encourage you to paint a wash in two colors? I will just say again that it is an excellent exercise for learning the techniques and skills involved in painting in wash, which is the first step in watercolor.

Fig. 281. Having seen the results that can be achieved with just two colors, why don't you try this or a similar exercise?

One thing is for sure: it will be good practice for painting in watercolor.

280

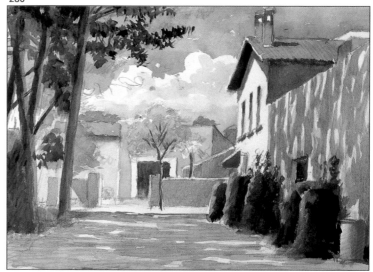

81

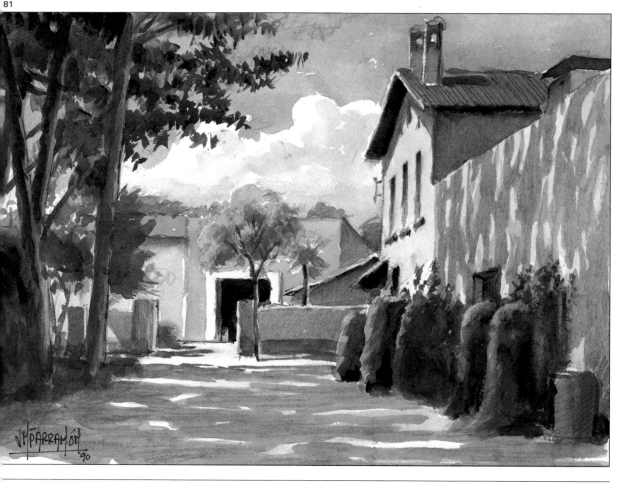

José M. Parramón paints a portrait in colored pencils

Here we are: model and painter, my wife and I. Handsome, isn't she?

You have guessed it: I am going to paint a portrait of my wife from this photograph, using the grid system. What is this? Cheating? Yes, but why not? All the grand masters of painting did it, and still do: from Leonardo and Dürer to Degas and Gauguin, all used grids to transfer and amplify a study into a full fledged painting. You should not think twice about using this system when you are painting a friend, spouse, or relative.

Figs. 282 and 283. The artist, me. The model, my wife.

Figs. 284 to 286. First, you have to get an enlargement of the photograph you are going to use as a subject. Next, you make it into a grid, which you also draw onto some vegetal paper, to help you get the line drawing of your portrait.

A
B
C

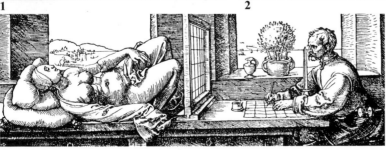

More out of curiosity than practical usefulness, take a look at a modern rendering, courtesy of an English publishing company, of the system invented by Albrecht Dürer (fig. 287, 3, at the bottom of the page) in which the master shows you how he draws looking through a frame containing a grid, using a pointed stick to guide him.

The system I will use here consists of a grid made with a ballpoint on a sheet of tracing paper framed in black cardboard (fig. 287, 1 and 2) which is placed near to the model so that the artist can draw, like Dürer, through the grid—except that, in this case, we do not use the guiding stick suggested by Dürer.

I am using *Gris Ciel* number 354 mi-Teintes paper by Canson, and I am using the side with the finer grain. My colored pencils are the range of 72 different colors by Rexel Cumberland, but they could just as well be by Faber-Castell, or Caran d'Ache (ranges of 80 colors) or another manufacturer. In fig. 289, you can see the range of 15 colors used in the painting of this portrait.

And so we get down to work: the first stage involves getting a double-size enlargement made. Next, I draw a grid over the photocopy (fig. 284) and then repeat this on a sheet of semitransparent vegetal paper, adding a smaller diagonal grid.

Now, to understand how to draw a picture from a grid, look at what I do in figs. 285 and 286. I draw the outline of the neck with a sharp HB pencil, noting that in the photograph this profile runs through points A, B and C, marked on the grid of the vegetal paper (figs. 284 and 285), so I draw in the line of the neck (fig. 286) and then check its position again with the gridded photocopy.

And so on. In fig. 288, you can see the the vegetal paper with the grid and the finished line drawing of my wife.

288

289
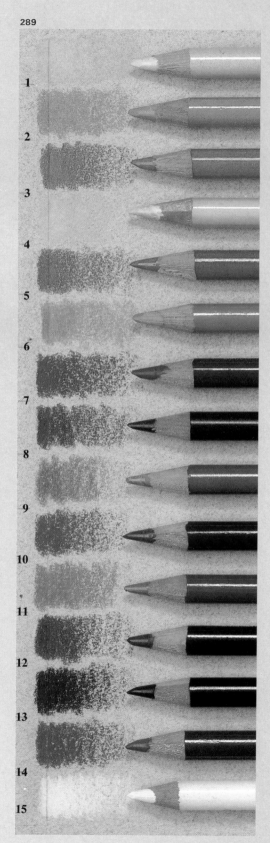

Fig. 288. The gridded vegetal paper with the portrait drawn onto it in lead pencil.

Fig. 289. The range of colored pencils that I used for this portrait.

1. Dark cadmium yellow.
2. Chrome orange.
3. Geranium laquer.
4. Light pink.
5. Garanza carmine.
6. Light blue.
7. Prussian blue.
8. Indigo.
9. Juniper green.
10. Burnt umber.
11. Dark umber.
12. Burnt carmine.
13. Black.
14. Gray blue.
15. White.

Transfer of the portrait to the drawing paper
Overall harmonization of the face and hair

Now we have to make the vegetal paper into tracing paper by covering the back with sanguine-colored chalk, the most appropriate color for tracing a portrait (fig. 290).

I attach the vegetal paper to the drawing paper at the top of both with adhesive tape and trace the drawing with a red ballpoint to make it more visible than the earlier pencil drawing (fig. 291). Careful though! Draw without pressing so that you do not get cracks on the drawing paper. While you trace the drawing, you can lift up the vegetal paper, holding the bottom of the sheet, to make sure that things are going well (fig. 292). In the following figure, number 293, you can see the traced drawing, without grid. I then softened the red tone of my tracing, which was too intense, by rubbing it gently with cotton wool (fig. 294).

Harmonizing the face and hair

I now paint the face with a light pink and burnt umber, later adding a layer of cadmium orange with a few touches of red in the cheeks. I draw the eyebrows and the eyes with burnt umber, but, for the moment, paint the iris and the pupil with carmine and burnt umber (fig. 295).

290

291
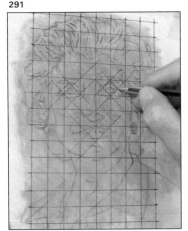

292

293
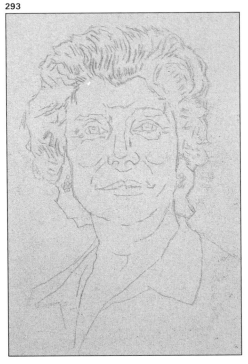

294
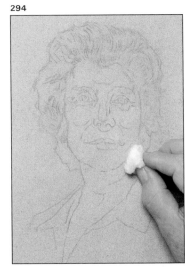

Figs. 290 to 294. The process of tracing the picture after painting the back of the gridded vegetal paper. This process is described in the text on this page.

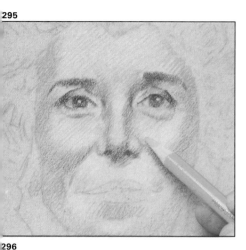

295

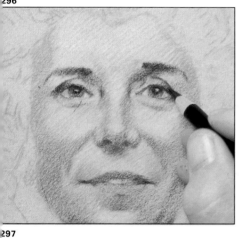

296

297

I reinforce the eyebrows and the shadows below with burnt umber, light blue, and juniper green, then the pupils of the eyes with an indigo, which, mixing with the carmine, becomes a warm black. I draw and paint the lips and mouth with garanza carmine, burnt umber and dark gray blue (fig. 296). Finally, I draw the hair, beginning by going over the basic lines again in Prussian blue (fig. 297), then work painstakingly on the details of lines, lights and shades, interpreting waves, shines and reflections. You have to take your time over this part of the work (fig. 298).

Figs. 295 and 296. I begin painting putting on general layers of light pink and dark umber, a color similar to a dark ochre, as well as some final layers of cadmium orange over the whole face and some red in the cheeks. After this, I carry on drawing and painting the eyebrows and the eyes themselves, using carmine, burnt umber, and blue, and carmine for the mouth.

Figs. 297 and 298. Now I paint the hair, first with a line drawing to get structure, then details provided by lights, shades, and reflections.

298

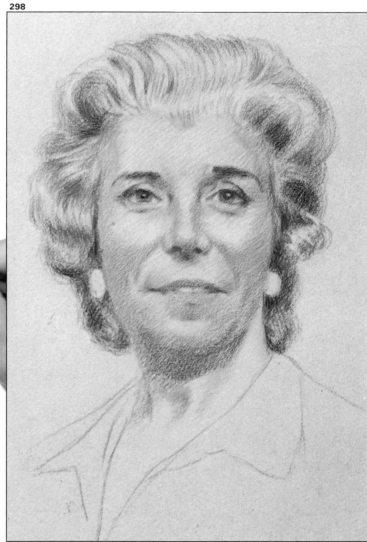

The last step: finish

The photographs on this page show the typical finishing touches to a portrait: scratching a few lines (fig. 299), highlighting whites here and there (fig. 300), modeling shades of colors like blues (fig. 301), painting the neck (fig. 302) and so on.

But the true finish can be seen in the completed picture on the following page.

I completed this last step two days later. I looked at the picture reflected in a mirror and checked and corrected the position of the right eyebrow, which was too high, the position of the mouth, a little off-center with respect to the nose, intensified the color of the face, and so on. Finally, I decided to draw a few lines of Prussian blue as a background and to highlight the blouse with a stroke or two of white pencil.

"You can sign it," said my wife. "I like it; we'll frame it."

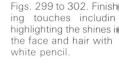

Figs. 299 to 302. Finishing touches including highlighting the shines in the face and hair with white pencil.

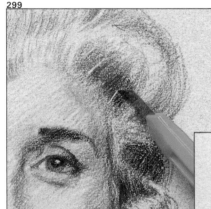

299

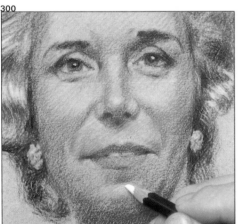

300

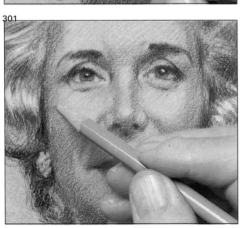

301

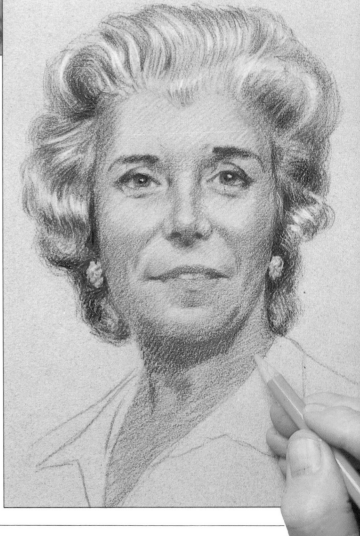

302

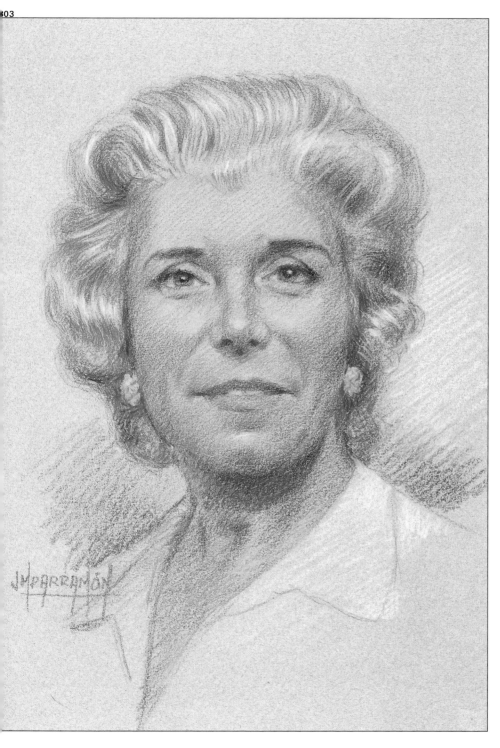

Fig. 303. The completed version of this portrait in colored pencils. Comparison of this with fig. 302 shows some important corrections I have made, such as lowering the right eyebrow, putting the mouth more in the center, and intensifying color. These changes were the consequence of waiting two days before pronouncing the portrait of my wife really finished, for then I was able to look at my work more objectively to see where the picture could be improved. I could spot my mistakes in part by examining the portrait reflected in a mirror, a method recommended by Leonardo for correcting mistakes in portraits and figures.

Francesc Crespo paints a bunch of flowers in pastels

The renowned artist, Francesc Crespo, teacher and ex-dean of the faculty of Fine Arts of Barcelona, is going to paint a picture of a jug containing several white daisies and two roses in pastels. Crespo is an expert who knows all the tricks and secrets of his trade, from working with just the right range of colors for each case to how to adjust the temperature of his studio in order for the flowers to stay more or less open, as if they had just been cut.

Crespo will paint in pastels on a sheet of white paper 70 × 50 cm (28 × 20''), using a range of 80 colors by Rembrandt. "Sometimes I use Lefranc colors," he says.

As you can see from the illustrations on this page, Crespo has a side-table on wheels, containing several drawers. There are also two trays with his 180 Rembrandt colors. By the side of these trays are two smaller boxes, each containing stumps of pastels—cold colors in

the upper box and warm colors in the lower. In the space in front of these two boxes, Crespo places the colors he uses during the painting of this picture, so that he can find them easily when he wants them again.

But let us see how Crespo begins his picture.

"First of all, I observe my subject," explains the artist. "I mentally calculate the height and width of the jug, the bunch of flowers, and the background, the space I will leave at the top, the bottom and at the sides. I imagine how the picture will look overall. The jug, the flowers, the background, when they are all transferred to the paper, and then...."

Crespo stops talking at this point and begins to draw with a dark gray chalk, sketching a series of circles to place the flowers, each circle indicating a flower (fig. 307). Quick and sure of hand, as one who knows what he is about, Crespo completes his drawing of the jug and

304

Fig. 304. Frances Crespo in his studio. A professor at the Facult of Fine Arts, Barcelona and an oil and paste painter, Crespo has had several exhibitions of hi paintings of flowers.

305 306

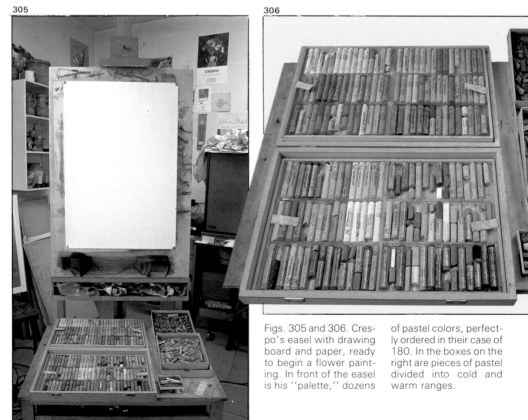

Figs. 305 and 306. Crespo's easel with drawing board and paper, ready to begin a flower painting. In front of the easel is his "palette," dozens of pastel colors, perfectly ordered in their case of 180. In the boxes on the right are pieces of pastel divided into cold and warm ranges.

Step one: the basic structure

flowers, then goes straight to work on the background, changing his gray chalk for an English red (fig. 308). If you observe the process of painting this picture through the illustrations on these pages, you will see that this idea of filling the white of the paper is a constant in Crespo's way of working.

"It's an urgent need," our guest artist explains, "To balance contrasts and to choose a particular color, you have to know what color the background is going to be, bearing in mind the law of simultaneous contrasts, which says that the lighter the surrounding color, the darker a color will be, and vice versa."

Crespo is still at the beginning stage of his picture, and he is more interested in form than in color.

Now he starts to paint the centers of the daisies a dark yellow, and around these he paints the petals with strokes of dark gray chalk, seeking the right place and proportions of the forms of the flowers, the leaves, the shaded spaces...

Let us pause for a moment at this juncture, to consider the importance of drawing.

308

Figs. 307 and 308. Crespo begins drawing, with sweeping strokes placing the flowers with circles, concentrating on their location and not worrying yet about details—leaves, petals or centers.

307

Step two: painting over a good drawing

All media, all techniques, demand that the painter, if he or she is a good painter, has a profound knowledge and understanding of the art of drawing. It is impossible to paint without drawing. This idea, often repeated and summed up in Ingres' well-known statement that "one paints as one draws," is especially evident in pastel.

Crespo's work at this point explains and confirms this rule. First, he adjusts the construction of his picture, drawing the flowers one by one, petal by petal, with well-defined strokes and outlines that correspond exactly to the forms of his model.

Watching him draw, we note how concerned he is with getting the structure right. He seems at first to place more importance on form than on color. But immediately his colors eliminate his drawn lines, color forms substitute the line drawing. Crespo works on this solid structure with great freedom, inventing, creating, as should when painting in pastels, for pastel colors allow you to paint light over dark, up to a certain point.

The ideal is for the artist to paint directly, without mixing colors, using the wide range of colors and shades at hand, painting over a perfect drawing.

309

Figs. 309 to 311. He draws more specific forms now, alternating this concentration on the details of the basic drawing with applying color which he quickly stumps with his fingers, blending them and blurring forms

310

311
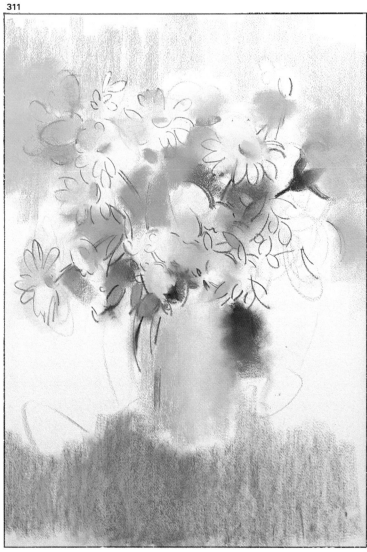

Step three: painting the background

In fig. 313, you can see how Crespo completes this stage, holding a rag in his left hand as he works. To give you an idea of the usefulness of this rag, we should point out that pastel sticks get dirty when they are broken and mixed with other colors, in the hand or in the boxes in which they are kept.

They are soon covered by a grayish, bluish or salmon-sienna film of dust that obscures and dirties their true colors so that you have to clean them with your rag. A quick rub is enough to do the job. Another method often used by artists is to try the color in the margins of the drawing board supporting the paper before using it (fig. 314).

Now Crespo begins to draw the background. From his warm range of pastel sticks he chooses a salmon-colored piece, a gray, an ochre, an English red, and a black. He begins to draw and paint, blending with his fingers, always with his fingers. "Do you see?" he asks. Look at figs. 315 to 318.

He finishes the background, or, rather, a general tryout of colors applied to the background.

Figs. 312 to 318. Some of Crespo's techniques for painting in pastel. Cleaning his pieces of pastel and his fingers after each stroke and stumping operation to make sure his colors are clean (fig. 313), trying out colors in the margin (fig. 314), drawing and layering colors with stumps of pastel (fig. 315) and blending with his fingers, always with his fingers, using all his fingers (figs. 316 to 318).

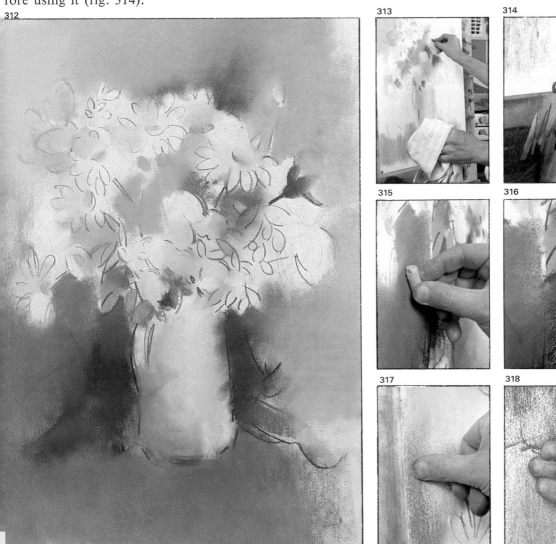

312
313
314
315
316
317
318

Step four: drawing and stumping

Crespo keeps painting, drawing, stumping with his fingers, superimposing and mixing colors, and cleaning, too, with his fingers and his rag. "You see, when you are blending with your fingers, it's a good idea to wipe them on the rag before going from one area to another, so as not to mix up all your colors and leave yourself with a symphony of grays," he says.

"Speaking of technique and skills," I say, "I notice you never use a rubber eraser or the rag to correct mistakes."

"No. Just occasionally I might use a kneadable rubber, the type you can make into any shape you want. With that you can erase, opening whites that delineate a petal or a thin stalk. But I think this way of working belongs to a meticulous style of painting, maybe hyperrealism, but not to the fresh, freer, looser language of diffused forms, closer to an impressionist style that I used here. Anyway, as you know, if you paint in that way, erasing and correcting shouldn't be done with a rubber or a rag. It's much better to paint over again to get rid of the line or shape you've got wrong."

We are at the last stage of the picture. Crespo is now wholly concentrated in working. He performs a series of actions over and over as if automatically. He draws, then stumps with his fingers, cleans his pastel or his fingers, looks at the model, shifts his gaze back to his picture, draws, stumps, cleans...

The final lesson in this last stage consists of looking back and observing the way the picture has been progressively built up, taking note of how Crespo has worked at all times on the overall picture, the sum rather than the parts.

Crespo interrupts me as I am dictating this and says to me, smiling, "Let me finish for you, Parramón. This is an idea I've explained time and time again in my classes at the Faculty of Fine Arts.

"The parts have to be subordinate to the whole. The work has to advance progressively. One part or detail must never have a value greater than that of the overall picture. You have to work on a picture all at the same time."

319

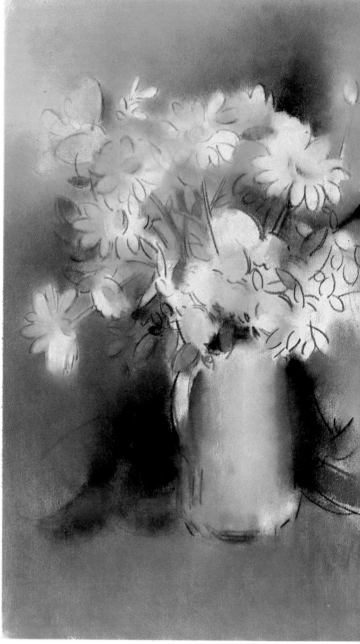

Figs. 319 and 320. If we compare the different stages of the picture, we get a perfect understanding of the idea expressed by Crespo when he finished this painting: "The parts must be subordinate to the whole. You have to work at the whole picture at the same time."

320

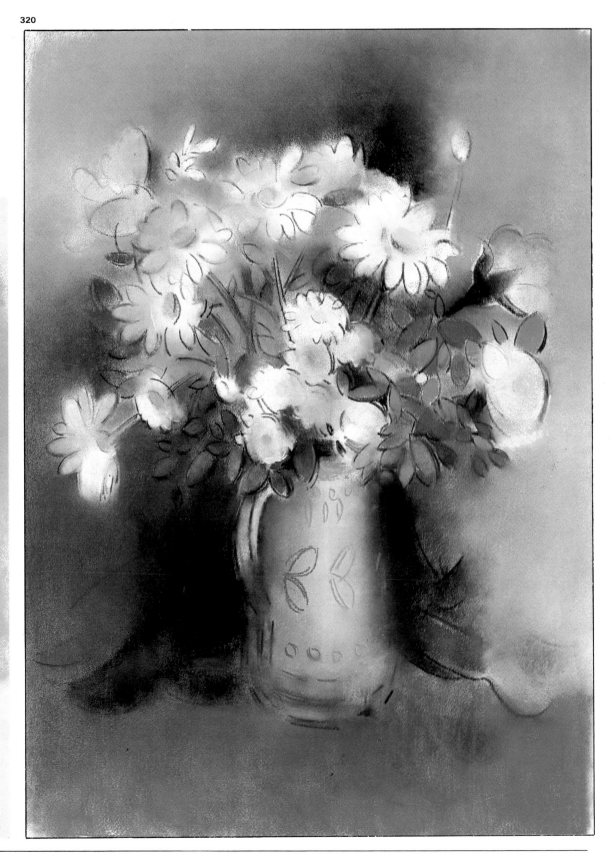

Miquel Ferrón paints a nude in colored chalks

Step one: preliminary sketch and initial structure

Ana, the model, is here with us. She is sitting in front of a background composed of a frame supporting a white cloth, which also covers a chair. Miquel Ferrón gets Ana to try various poses, standing, sitting, with her legs crossed, and finally he chooses the pose you can see in fig. 321.

In figure 322, you can see the materials Ferrón is going to use: a Conté crayon, a set of rather hard colored chalks, various charcoal pencils of different gradations and a kneadable rubber eraser, ideal for working in charcoal and chalk. He is going to use Canson mi-Teintes ochre-gray paper, 110×75 cm (44×30") which he has cut down to 100×70 cm (40×28") leaving a margin of some 4 centimeters on the right-hand side to be used for trying out colors. He will make his preliminary sketch in charcoal pencil, stumping with his fingers and a rag, as we will see later on.

He begins the session by marking a preliminary sketch, which he will keep

322

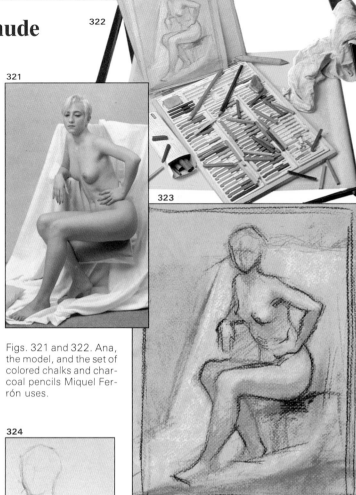

321

323

Figs. 321 and 322. Ana, the model, and the set of colored chalks and charcoal pencils Miquel Ferrón uses.

324

Fig. 323. A first, small sketch to study the pose and structure Ferrón will use in his full-sized picture.

Figs. 324 and 325 Drawing the structure with charcoal pencil.

325

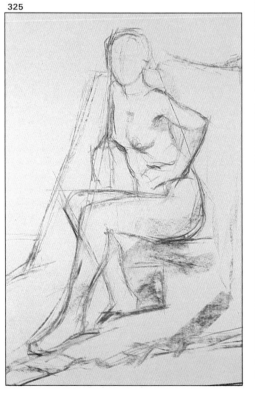

326

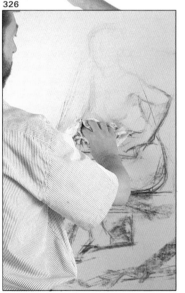

327

Step two: sketching in sanguine

328

329

at hand while he completes the defini-
tive drawing, which will be large enough
to mean working with a drawing board
supported on a studio easel. You can see
his equipment in fig. 342 on page 109.
He draws in charcoal (figs. 324 and 325),
then immediately rubs his work out with
the rag, as you can see in figs. 326 and
327.
"Why does he draw and then rub it all
out?" you may well ask. The reason is
that rubbing out charcoal does not re-
move all traces, as you can appreciate
from close examination of fig. 327. You
can draw over, reconstructing on top of
your first drawing, correcting and ad-
justing the construction of the original
sketch.

**Step two:
sketching in sanguine**
Ferrón structures and draws definitive-
ly now, using sanguine to draw outlines
and profiles or, holding his stick flat
against the paper, gray areas and grada-
tions (figs. 328 to 330).
When he comes to the legs and feet, he
slightly darkens his tone to match the
more intense shade that these parts of
the body usually present (fig. 331).

Figs. 326 and 327. Fer-
rón erases the initial draft
so that he can draw over
it, reconstructing to make
his definitive drawing.

Figs. 328, 329 and 330.
Painting only with san-
guine, alternating draw-
ing with the tip of the
chalk for lines and pro-
files or holding the san-
guine flat against the
paper for graying and

grading, Ferrón achieves
an initial modeling of his
nude.

Fig. 331. This is how the
nude looks at the end of
the second stage. The
figure now shows the be-
ginning of valuing tones.
There is greater intensi-
ty of tone in the legs and
feet, but the features of
the face are still incom-
plete.

330

331

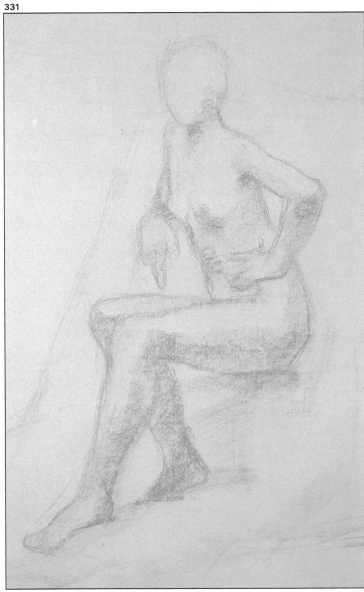

Steps three and four: blending and studying values

Ferrón begins this third stage by adjusting the drawing of the face of his model with a few lines placing the eyes, nose, and mouth. Then he works on modeling, still using sanguine, drawing and blending with his finger wrapped round the rag or directly with his thumb (figs. 332 and 333). This stumping phase involves a study of values, which our guest artist carries out by reinforcing his sanguine, modeling lights and shades, reflections, and the parts in darker shadows. In fig. 334, you can see how the picture looks at the end of this stage.

another, looking at the model, then back to the picture, looking at the model again ... coming and going all the time. "For now, as you can see," says Ferrón, "I'm working with a direct line, without stumping. Later, when construction, value, and contrast are more advanced, I'll stump a few areas. But I won't erase all traces of my direct drawing. I'll highlight the structure or grain of the paper to get a fresh, spontaneous finish."
He completes this stage by drawing a number of lines of white chalk on the cloth in the background.

332

333

334

Intensifying modeling and highlighting with white chalk

Now he begins to define forms, accentuating or intensifying modeling with the dark sepia chalk, working as Corot did, "from top to bottom," but also following Ingres' advice to "be in everything, seeing everything, doing it all at the same time." That is how Ferrón works on his picture, beginning with the head and finishing at the feet, but always comparing forms, dimensions, proportions, values, contrasts of one area with

335

336

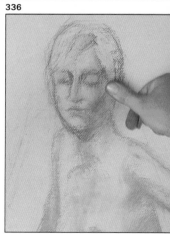

Figs. 332 to 334. Ferrón begins to construct the face—eyes, nose, and mouth—but not with great precision as yet. He softens the grays and gradations of the previous stage, blending colors with a rag and his thumb, without using a stump.

Figs. 335 and 336. Now we can see that our guest artist has begun to define the face using a dark sepia chalk.

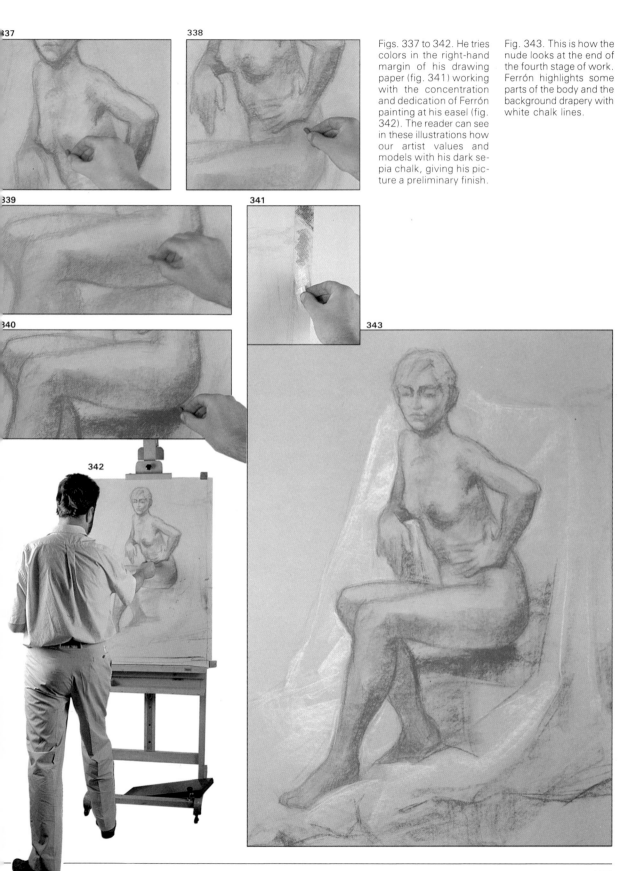

Figs. 337 to 342. He tries colors in the right-hand margin of his drawing paper (fig. 341) working with the concentration and dedication of Ferrón painting at his easel (fig. 342). The reader can see in these illustrations how our artist values and models with his dark sepia chalk, giving his picture a preliminary finish.

Fig. 343. This is how the nude looks at the end of the fourth stage of work. Ferrón highlights some parts of the body and the background drapery with white chalk lines.

Step five: the finish

Ferrón begins this final phase by high-lighting the lights and shades of the model. For the face, he uses a pink chalk (fig. 344); for the thigh, a light Naples yellow (fig. 345). In some shaded areas, he uses light touches of charcoal pencil, which he quickly stumps (fig. 346). For the knee, he uses a little white chalk (fig. 347), then highlights the hair with light yellow (fig. 348). Blue works for the areas in shadow, as does dark sanguine pencil to outline the hands (figs. 349 and 350). Finally, he goes over certain parts of his picture with light blue, light green, violet, red, and carmine.

Here is the final result, fig. 351, one more example of the possibilities of the art of drawing.

Figs. 344 to 350. Ferrón is everywhere at once now, drawing and painting everything, highlighting whites and shines, graying, grading, intensifying. He doesn't use just the basic colors in which he constructed and modeled almost the whole of his nude, sanguine and dark sepia, but a whole range of colors—pink. Naples light yellow, green, violet, carmine, even charcoal. He is working with a passion, "from top to bottom," doing everything, working on the totality of his painting.

344

345

346
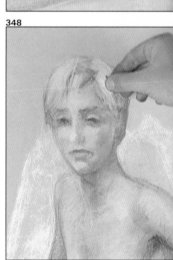

347

348

349
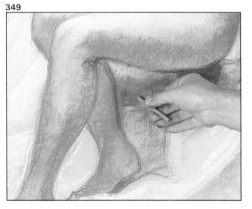

350
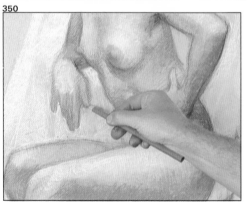

351

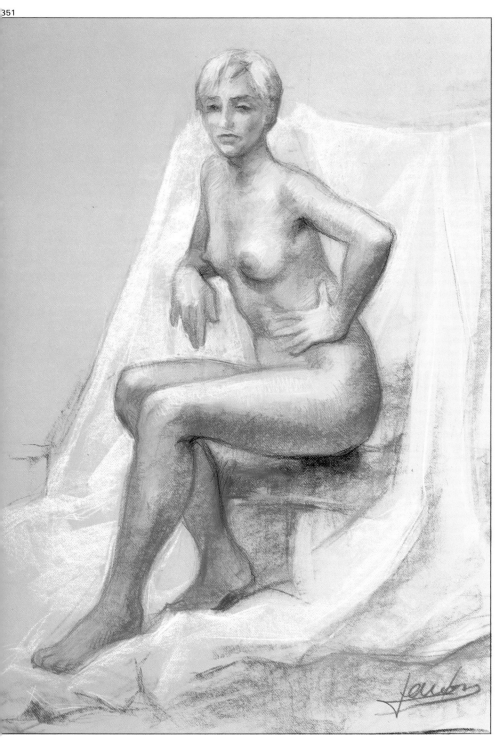

Fig. 351. The finished painting, with perfectly completed structure and construction. Ferrón employed a loose, free language, and avoided overdoing the finish. There is a fine harmony of the colors he has used and the paper. He has not dramatized highlights with his soft colored pencil, but has let the cloth in the background remain there. He focuses attention on the model. A fine example with which to close the pages of this book on the art of drawing and how to draw.

Acknowledgments

The author acknowledges the cooperation of artists Vicenç Ballestar, Miquel Ferrón, and Francesc Crespo, as well as Teixidors's cooperation for lending drawing and painting materials from their art store.